Carolingian Painting

CAROLINGIAN PAINTING

Introduction by

FLORENTINE MÜTHERICH

Provenances and Commentaries by

JOACHIM E. GAEHDE

George Braziller New York

Published in 1976.

For information address the publisher:
George Braziller, Inc.,
One Park Avenue, New York, New York 10016

Library of Congress Cataloging in Publication Data

Carolingian painting.

 Bibliography: p.
 1. Illumination of books and manuscripts,
Carolingian. I. Mütherich, Florentine.
II. Gaehde, J. E.
ND2950.C37 745.6'7'094 76-15908
ISBN 0-8076-0851-3
ISBN 0-8076-0852-1 pbk.

First Printing

Printed by Mohndruck in West Germany

BOOK DESIGN BY RON FARBER

COVER DESIGN BY MIKE FIRPO

Contents

Acknowledgments

The authors and the publishers would like to express their sincere thanks to the following institutions and individuals who kindly provided materials and granted permission to reproduce them in this volume.

Color Plates

AACHEN, Ann Münchow, Fotografin, Plates 13, 14, 15, 27.

BERLIN, Staatsbibliothek Preussischer Kulturbesitz, Plate 17.

BERN, Burgerbibliothek, Plates 11, 16.

LEIDEN, Bibliotheek der Rijksuniversiteit, Plates 18, 19.

LONDON, The British Library, Plate 20 (reproduced by permission of the British Library Board).

MUNICH, Bayerische Staatsbibliothek, Plates 35, 36, 37, 38.

PARIS, Bibliothèque Nationale, Plates 1, 2, 3, 4, 5, 6, 7, 21, 22, 23, 24, 25, 26, 28, 29, 30, 31, 32, 33, 34, 48.

PRAGUE, Kapitulni Knihovna, Plates 39, 40, 41.

ROME, Abbazia di San Paolo fuori le Mura, Plates 42, 43, 44, 45 (reproduced by permission and with cooperation of Propyläen Verlag, Berlin).

ROME, Vatican City, Biblioteca Apostolica Vaticana, Plate 12.

ST. GALL, Stiftsbibiothek, Plates 46, 47.

VIENNA, Kunsthistorisches Museum, Schatzkammer, Plates 8, 9, 10.

Black-and-White Figures

BERN, Burgerbibliothek, Figure V.

PARIS, Bibliothèque Nationale, Figures III, IV.

TRIER, Stadtbibliothek, Figure VI.

UTRECHT, Bibliotheek der Rijksuniversiteit, Figures I, II.

Introduction

"Carolingian" as a historical term covers the reigns of Charlemagne (768–814) and his successors; as an art historical term, however, it does not cover the same period. Charlemagne became king in 768 and after the death of his brother in 771 was sole ruler over the Franks. But the first work that art historians describe as Carolingian, the Godescalc Evangelistary (Plates 1–3), was executed only between 781 and 783. And when the last of the Carolingians, Louis V, ruler of the western half of Charlemagne's empire, died in 987, the artistic production of his territories—both meager and insignificant—came under the general heading of pre-Romanesque; Carolingian it certainly is not. Carolingian art grew out of and was nourished by the idea of the rebirth and renewal of cultural life initiated by Charlemagne, and only in rare and limited instances did it survive beyond the end of the ninth century.

It may be chance that the earliest surviving work illustrating this spirit of renewal in art is a manuscript. Nevertheless, that fact serves as a reminder of the historic role that manuscripts were destined to play in the evolution of the Carolingian *renovatio*. To achieve the goals promoted by Charlemagne, books were essential—books for churches and monasteries, for schools and libraries, books for reading and prayer.

In three great edicts and proclamations issued in the decades from 769 to 800, Charlemagne laid the foundations for the formidable task of reviving culture and learning in a land that was in a state of decline and had even lapsed into barbarism. To learn, was Charlemagne's first command: *studium discendi*, zeal of learning, was strictly required, and one of the most famous passages of Einhard's Life of Charlemagne is the description of the Emperor himself keeping tablets and booklets under his pillow for use during hours of rest (Einhardi Vita Karoli Magni, cap. 25; Mon. Germ. Hist. Script. Rer. Germ., 1911). A certain amount of knowledge was now made obligatory for the clergy. Reforms and improvements were prescribed for the liturgy and divine service, and above all for the worthy celebration of the Mass. Charlemagne turned his attention to civil and ecclesiastical law, to the calendar and computistic tables, to history and grammar, to the writings of the Church Fathers, as well as to the works of poets. He not only set the objectives but provided the means to achieve them.

Of the schools that bishops and monasteries were ordered to set up, the most famous was at his court, and the largest collection of books was in his own library, which we can still reconstruct in part today. To fill the gaps or replace

corrupt texts, Charlemagne sent for books from Rome or Monte Cassino and commissioned the scholars gathered around him to correct the existing manuscripts. Texts for use in the Frankish kingdom were to be "correct" and "uniform," to be "well edited" and executed "with all possible care." These words appear again and again in the sources, and the famous note *"ex authentico libro,"* attesting in so many Carolingian manuscripts to the authenticity of a copy, is to be found not only in liturgical codices, but also in scholarly tracts.

Thus new editions of Bibles were produced, a revision of the Gospels was prepared, and the Psalter was provided with additions and supplements. A new book for the Mass was introduced—a Sacramentary, based on a model sent at Charlemagne's request by the Pope. Homiliaries were made to Charlemagne's order, and the so-called *Libri Carolini* presented the views of the Carolingian Church on the iconoclastic controversy. An assembly of scholars, held at the court of Aachen in 809, produced an astronomical and computistical handbook. The laws of the Germanic nations were collected. For canon law, a codex sent by Pope Hadrian served as model. So many patristic and literary texts of all descriptions were copied that it would be impossible to list all the titles and subjects here. To produce these works a large number of scribes was assembled or trained at court: *turba scriptorum*, the crowd of scribes, as they are called in one of Alcuin's poems (Mon. Germ. Hist. Poet. Lat. I, p. 246).

The most important of these books, however, were those master copies, or *exempla*, intended for dissemination throughout the empire. That they were indeed disseminated we know from examples that still exist or appear in surviving library inventories. It was Charlemagne's intention that his example should be followed everywhere, and with this end in view he sent not only books but also those whom he had gathered around him, outstanding personalities of the age, to all parts of the empire. Alcuin, the Anglo-Saxon, was dispatched to Tours; the West-Goth, Theodulf, to Orléans; the Frank, Angilbert, to Centula; the Bavarians, Leidrad and Arn, to Salzburg and Lyon; the Langobard, Paulinus, became archbishop of Aquileja, to mention only a few—all authors, scholars, lovers of books. Later, too, under Charlemagne's successors, the great patrons and bibliophiles came from the court. Among them were Ebo of Reims and Drogo of Metz, Hilduin of Saint-Denis, Adelhard and Vivian of Tours.

The codices produced at court were intended to be examples in more than their content or text. The same standards were made to apply to the manuscripts themselves, their layout, their script, their decoration. There had been earlier attempts, we know, to stem the decline and avert the decay of Frankish book production. But none of these had met with any wide-reaching or lasting

success. The most telling evidence comes from that integral part of a manuscript—the script itself. In the course of the eighth century there had been attempts here and there to reform the degenerate alphabets, but all efforts remained limited and without general effect. The turning point came with Charlemagne. A new script, the Carolingian minuscule, was disseminated throughout his domains.

Developed from cursive, the everyday script of the late antique, Carolingian minuscule complied with two basic requirements of Charlemagne's reforms: order and uniformity. It was practical and economical and, written by trained Carolingian scribes, it presented impressive examples of calligraphy. The ancient majuscule letters were restored to their classical forms and used together with the new minuscule for display script; for setting off titles, headings, or endings; and even for entire pages in sumptuous manuscripts. By carefully alternating different types of lettering a scribe could give clarity and articulation to a page or an entire book, and in the course of the ninth century, pages were produced that are among the calligraphic masterpieces of all time.

The triumphal progress of the new script was one of the most important and lasting achievements of Charlemagne's reform. Through the humanists of the fifteenth century, Carolingian minuscule became the basis of the modern Roman alphabet, so that today it still marks the pages of our books.

If we ask why Charlemagne succeeded where others had failed, the answer is simple. The letter which he sent out with the collection of homilies of Paul the Deacon states that the work, commissioned by him, was henceforth confirmed by his authority (Mon. Germ. Hist. Capt. I, No. 30). This *nostra auctoritate constabilimus* accompanied and guaranteed the whole Carolingian reform—and the success of Carolingian minuscule.

It is therefore not a matter of chance that a manuscript commissioned by Charlemagne and executed by a court scribe, the Godescalc Evangelistary, occupies a decisive place in the history of Carolingian script, and that it is, moreover, also the first indication that a new epoch in the history of manuscript painting was opening. The Godescalc Evangelistary represents a program that was to be developed and perfected to an ever more brilliant degree in subsequent manuscripts made at Charlemagne's court, and from here it spread throughout the empire (Plates 1–7).

The aim of the artistic revival proclaimed at court was the renewal of classical art. This implied a perception of the three-dimensional figure in space and of the specific, organic relation of the parts to the whole, effects that could only be reproduced by mastering illusionistic techniques as they had been developed in late antique painting. For the ornamental decoration of manuscripts, however, forms were adopted that originated in the Insular art of

the North—the great initial pages as well as many of the individual motifs which we find next to classical patterns. Characteristic is the clear distinction of image and ornament, the reluctance to transpose organic forms into an inorganic context that had been typical of whole regions in the eighth century.

The Court School was followed along this path by those groups of manuscripts that can be described as representative of a "renaissance." At the court itself there were the codices grouped around the Vienna Coronation Gospels; then came Reims, Tours, Metz, the Court School of Charles the Bald, and a number of other centers both large and small. Such works as the Vienna Gospels (Plates 8–10), the Utrecht Psalter (Figures I–II), the Leiden Aratus (Plates 18–19), the Drogo Sacramentary (Plates 28–29), the miniatures and decoration in the Tours manuscripts (Plates 20–26), as well as the sumptuous codices of Charles the Bald (Plates 32–38) provide impressive testimony to an art that after hundreds of years awakened a sunken world.

But this was not the only aspect of book painting in the ninth century. Apart from the Renaissance schools, there were other scriptoria where the classical heritage found only slow acceptance or even outright rejection. Provincial centers held fast to the old ornamental repertoire, the foliate or animal initials of the Continental tradition, and where miniatures do appear, they are with few exceptions of antiquarian rather than artistic interest. Of great importance, however, are those schools, located in the great monasteries near the coast of northern France, which employed almost exclusively a purely decorative repertoire drawn from linear, unnaturalistic forms of Insular origin, but which produced with them such masterpieces of graphic art as the Second Bible of Charles the Bald (Plate 48). Miniatures are exceptions in these manuscripts. It is one of the most fascinating chapters in the history of Carolingian manuscript painting to trace the course of the two currents—their parallel and even contrary paths, and their occasional contacts when the abstract world could not resist the attraction of pictures (Plates 17, 30–31, 39–41, 48).

Better than almost any of the other arts of the Middle Ages, Carolingian manuscript painting illustrates the continuity of a tradition that lies at the very foundations of Western culture. The product of a unique historical situation, it developed in the course of a century a number of different aspects which can still be followed in surviving manuscripts.

If we consider the beginnings of Charlemagne's Court School in this light, the Godescalc Evangelistary can be seen as a daring experiment, which would explain its imperfections and shortcomings. Although in his verses Godescalc speaks only of its material value—the purple of the parchment and the gold and silver of the script—he was fully aware that he had created an exceptional

and extraordinary work. The next Court School manuscript with figural representations known to us dates from more than a decade later. Even the Psalter written in gold on purple parchment and made to the order of Charlemagne for presentation to the Pope (Vienna, Nationalbibliothek, Cod. 1861) has only ornamental decoration. This interval explains the disparity between the later Court School codices and Godescalc's book. From the nineties onward Court School painters exhibit an entirely new freedom and independence. To be sure, different models played a part, older models that were still filled with the breath of the antique which henceforth lived on in the powerful figures of the Evangelist portraits. In combination with the incredible splendor of the Canon tables, of the magisterial introductory miniatures and the monumental initial pages, these images lent to manuscripts such as the Soissons Gospels (Plates 4–7) that imperial aspect which has become known as the "style Charlemagne."

One of the most surprising phenomena in the history of Carolingian art is that side by side with the Court School a work such as the Vienna Coronation Gospels could be produced. It embodies a very different aspect of antique art —the classic in a true sense. Both the understanding of the human form that is shown here in the Evangelist portraits, figures of antique philosophers, and the painterly technique of execution are based on models that extend back to the Hellenistic tradition of late antiquity. That such models were used appears also from the classical architectural forms of the Canon tables and from the reserve of that specifically medieval feature—the decorated initial. Beside the monumentality of the Court School we now find the dignity of the classic, and this dual heritage was passed down after Charlemagne's death to the sons and grandsons (Plates 8–10).

The Court School left its traces principally in the East Frankish part of the empire, where Fulda, Salzburg, Mainz, and Lorsch copied its Gospel Books. In the West it was above all the splendor of the Soissons Gospels (Plates 4–7) that influenced the style of the luxury manuscripts of the Court School of Charles the Bald (840–877), Charlemagne's grandson (Plates 35–38). The influence of the Vienna Coronation Gospels continued to make itself felt at the court itself until the middle of the ninth century, when Aachen played a part in Carolingian manuscript painting for the last time through the Court School of Emperor Lothair (840–855). But before this the style had found its true follower in the school of Reims, and from there, clothed anew, it was transmitted to all parts of the empire, extending even to distant Bavaria, as a group of Gospels executed in Freising in the third quarter of the century shows.

Little is known about book illumination at the court of Charlemagne's son, Louis the Pious (814–840). But it is obvious that in the second quarter of

the ninth century the court and its entourage became the center of a truly humanistic movement to preserve and propagate the literary, scholarly, and artistic patrimony of the ancient world. A series of striking copies of important late antique picture cycles bears witness to these interests, which seem to have been encouraged by the Empress Judith (+843). Already under Charlemagne, the astronomical handbook issued about 810 had been provided with a series of illustrations of the constellations which, judging from a later copy, were faithful reproductions of a late antique original (Plate 27). Now, a compendium of texts on surveying (Rome, Biblioteca Vaticana, Pal. lat. 1564) appears, and the first copy of an illustrated fifth century codex of the Comedies of Terence (Rome, Biblioteca Vaticana, Vat. lat. 3868) was made in the surroundings of the court (see also Figures III–IV). A cycle of the Labors of the Months, known to us from a later copy (Rome, Biblioteca Vaticana, Reg. lat. 438), was dedicated to Lothair I. The famous Calendar of the year 354, lost— as was its Carolingian copy—and preserved only through sixteenth and seventeenth century drawings, has been traced to the court of Louis the Pious.

Above all, however, what fascinated these Carolingians were the antique representations of the constellations in their combination of astronomical and mythological aspects. Of the various versions of the most important astronomical text of the ancient world, the *Phainomena* of Aratos, some have been handed down to us complete with their late antique illustrations. Thus Cicero's version, mentioned in the letters of Carolingian humanists as "Tullius in Arato," has been preserved (London, British Library, Harley Ms. 647) as well as the famous *Aratea* of Germanicus Caesar, the Leiden copy of which is one of the finest Carolingian reproductions of an antique codex. Not without reason are its miniatures so often reproduced. The oldest copy dates from the end of the tenth century (Boulogne, Bibliothèque Municipale, Ms. 188), and even in the year 1600 Hugo Grotius, the Dutch humanist, used them to illustrate his *Syntagma.*

Various schools repeated many of these picture cycles and added others, such as the copy made in Reims of a late antique *Physiologus* (Plate 16). But often the later manuscripts ceased to be true copies. Only the iconography of the ancient models was retained; in style they were transposed, like the Reims Terence (Figures III–IV), into the idiom of the ninth century.

Much the same is true of illustrations to texts that were not classical, produced, to be sure, outside the circle of humanists. The well-known Trier Apocalypse preserves a Roman cycle of the sixth century (Figure VI), and the contest between Virtues and Vices described in the *Psychomachia* of the Spanish poet Prudentius (+ after 406) is repeated in numerous copies, of which the Bern codex is the most important (Figure V). In the same category, though

more as an imitation than as a copy, belong those strange products of Carolingian poetic art, the figure-poems of Hrabanus Maurus (Plate 12), based on the *carmina figurata* of Optatianus Porphyrius, court poet to Constantine the Great. How much poorer would our knowledge of the lost manuscripts of the late antique world be without all these facsimiles of secular and religious picture cycles!

The center of Carolingian manuscript painting in the first two decades after the death of Charlemagne was, however, not the court, but Reims, seat of Bishop Ebo (816–835, 840–845). Childhood companion of Louis the Pious, Ebo had become Archbishop of Reims soon after Louis's accession to the throne, but his enthusiastic defense of the unity of the empire led him to transfer his support from Louis to his son, Lothair, and resulted in Ebo's banishment. It is Ebo who employed those artists who in the intense liveliness of their paintings created a new variant of illusionistic art, antique in origin, yet an outstanding example of medieval expressionism. The interpretation of an Evangelist as an author filled with inner emotion, as found in the Ebo Gospels (Plates 13–15), is as far removed from the monumental figures of the Court School as it is from the classical repose of those in the Vienna Coronation Gospels. The contrast of the classical architectural elements and the antique genre scenes in the Canon tables with the abstract golden interlace of the initial pages exhibits once again the characteristic Carolingian faculty of combining different elements to create a new unity. The mingling of antique and Carolingian worlds is most striking in the spirited illustrations of the Utrecht Psalter. The crucial problem of its model remains a matter of passionate scholarly discussion and will probably never be completely solved (Figures I–II).

Meanwhile in Tours, in the venerable monastery of St. Martin, patron saint of the Franks, a school was developing that was to become the model and teacher for Early Medieval manuscript painting. Alcuin (796–804) laid the cornerstone with the great single-volume Bibles that Charlemagne ordered him to edit. Like those produced by Theodulf of Orléans, his books are unillustrated, although for different reasons. While the Touronian Bibles reflect the first steps of a young school, Theodulf's precious codices demonstrate once again the attitude of the author of the *Libri Carolini,* who would not allow the image in a holy book. Also a copy of the Gospels made for him has only a miniature of the four Evangelist symbols (Plate 11).

About 830, however, Tours began to add miniatures to its manuscripts. A Gospel Book now in Stuttgart (Württembergische Landesbibliothek, Ms. II 40) is the first of a whole series of magnificent codices—Gospels, Sacramentaries and Bibles—produced under the Abbots Adalhard (834–843) and

Vivian (844–851). A fixed cycle of illustrations for Gospels consisting of a *Maiestas Domini* and the Evangelist portraits was created, destined to persist for hundreds of years. Towards the end of the thirties Bibles too were given illustrations. Two of these pandects have survived (Plates 20–23); others can be reconstructed from fragments, or derived from literary sources and later copies. Their monumental miniature pages, based on late antique Bible illustration, surpass the achievement reached a century earlier in the British Isles, where Anglo-Saxon scribes and painters had revived for the first time in the North the tradition of Bible production.

When the school of Tours reached its apogee the painters had transmuted their antique and Carolingian heritage into new and lucidly displayed forms, more expressive of the aims of classical art than the works of any other Carolingian school. This is particularly consistent in the ornamental decoration of their manuscripts—in the clear silhouette effects of the gold and silver vines and figures. The crowning achievement of the middle of the century was the Lothair Gospels (Plates 24–26), the masterpiece of the greatest of Touronian painters, known in art history as Master C of the Vivian Bible, the name given him by Wilhelm Koehler.

The high point was soon followed by the end. In 853 Tours was plundered by the Normans, and the school never recovered from that blow. Among its patrons had been nobles, bishops and abbots, the Emperor Lothair, and King Charles the Bald. The Empress Irmingard also possessed a Touronian copy of the Gospels, now in Wolfenbüttel (Herzog August Bibliothek, 16. Aug. fol). Codices made in Tours can be traced in almost all important centers of the empire, and Tours became the *magistra* not only of her own but of the following centuries.

Around the middle of the ninth century, Metz, following Reims and Tours, rose as a third star in the sky of Carolingian illumination. Once again the motive force came from a man from Charlemagne's court—Drogo, illegitimate son of the Emperor, appointed Bishop of Metz in 823 and Archbishop in 844. A small group of precious manuscripts made for him in the fifteen years prior to his death in 855 marks a high point in Carolingian book painting. These manuscripts are among the most beautiful testimonies to the Carolingian Renaissance.

The best copy of the cycle of the constellations produced at Charlemagne's court has been connected with Drogo (Plate 27). Liturgical manuscripts made for his own use—and in particular the Sacramentary (Plates 28–29) bearing his name—display a unique and imaginative blend of classical acanthus decoration with miniatures in the antique, illusionistic style. Small figures and scenes set within the initials revive the motif of the historiated initial. First appear-

ing in Insular manuscripts of the eighth century, then adopted by pre-Carolingian artists, it had been used in Charlemagne's Court School and was destined to play its most important part in the ornamental achievements of Romanesque art. In this development the Drogo Sacramentary is one of the most interesting as well as most beautiful steps. The delicate small scenes are often of great iconographic interest as they preserve part of one of the very rare New Testament cycles to appear in Carolingian book painting.

As Archchaplain, Drogo held the highest post in the land until his death. Like Ebo, he was deeply committed to the idea of the Carolingian empire as it had been built up by Charlemagne. But he was an unflinching supporter of his half-brother, Louis the Pious, and after Louis's death he acted as a wise and prudent adviser to his nephew, Lothair I. Drogo was only a child when he lived in his father's household at Aachen. Nevertheless the works of art that were made for him in his own residence seem to preserve some of the lustre of Charlemagne's court.

The second half of the ninth century was dominated principally by two different, even controversial schools: a Court School and a monastic school— the first working for a patron, producing a variety of sumptuous books, the second working for export, repeating standard types for liturgical practice; the first combining the achievements of a century, the second limiting itself to a repertory of mainly ornamental forms. The first school is connected with the great Emperor's grandson, Charles the Bald (840–877). It must be considered as his Court School even if we are still uncertain where it was located. Charles is named in numerous dedicatory poems, litanies and prayers, and his portrait clearly connects several of the manuscripts to him. His Prayerbook in Munich (Schatzkammer, Residenz), his Psalter in Paris (Bibliothèque Nationale, lat. 1152), and the exceptionally rich Gospels, the *Codex Aureus* (Plates 35–38), provide us with a solid framework for associating and classifying other manuscripts. Text, script, ornament and the miniatures link the various manuscripts together, and furthermore, the name of the scribe Liuthard, who identifies himself in the Paris Psalter and again—together with his brother Beringar—in the Munich *Codex Aureus,* appears already in one of the earliest manuscripts of the Court School (Darmstadt, Landesbibliothek, Ms. 746). So in spite of the eclectic character of the group the connection between its manuscripts is clearly established.

The early works of Charles the Bald's Court School show some links with Metz, and it is obvious that Reims too played a part in its development. Around 870 elements from Tours came principally to the fore. This is the time when, in such manuscripts as the Paris Sacramentary fragment (Plates 32–34) and the Munich *Codex Aureus,* there are the greatest number of splendid miniatures

and the richest display. Besides gold and silver, simulated precious stones and porphyry are used increasingly to decorate the borders of the pages, and it is surely not a matter of chance that one of Charlemagne's most sumptuous manuscripts, the Soissons Gospels (Plates 4–7), can be recognized in the Canon tables and the borders of the text columns of the *Codex Aureus*. The uncial script laid out in double columns also leaves no doubt as to the connection with the Soissons Gospels and, therefore, with the Court School of Charlemagne. It cannot be fortuitous that the portrait showing Charles the Bald enthroned opposite a miniature of the Four and Twenty Elders adoring the Lamb (Plates 37–38) depicts the same scene that Charlemagne saw as he looked up from his throne at the dome mosaic in his Aachen chapel. Charles's greatest ambition was to be like his grandfather, whose name he was proud to bear. And in these years, he may have thought he was a step nearer this goal when, after the death of his nephew Lothair II, he extended his hand to the central part of Charlemagne's empire.

From the same period dates a monumental codex executed for Charles the Bald, though not actually at his Court School. Once again Carolingian art made, as it were, a compendium of everything that had been done in the previous decades. This compendium was the Bible of San Paolo fuori le Mura (Plates 42–45), which was almost certainly among the famous gifts offered by Charles to the Pope in 875 to gain the imperial crown. With its twenty-four full-page miniatures to the Old and New Testaments, it far surpasses the Touronian Bibles of the first half of the century (Plates 20–23), although a certain number of the miniatures clearly derive from Tours. The remainder depend on sources that point to other connections.

Whereas the miniatures of the Bible and those of the later manuscripts of Charles the Bald's Court School have features in common—due partly to the use of the same or related Touronian models—the splendid initial pages and the great golden single capital letters come from another source: the late art of Reims. Thus the Bible of San Paolo grew out of a combination of the great Carolingian schools of Tours and Reims with the Court School of Charles the Bald. When Ingobert, the scribe of the Bible, addresses the ancient calligraphers, the *graphidas Ausoniae*, as his equals, it brings to mind the proud words from the time of Charlemagne: "Golden Rome is born again on earth." (Mon. Germ. Hist. Poet. Lat. I, p. 385.) Yet for all Ingobert's self-assurance, the style of the Bible of San Paolo, like that of the late manuscripts of Charles the Bald's Court School, indicates that the zenith is passed and that the end of the Carolingian Renaissance is not far away.

It is true that towards the end, Carolingian manuscript painting also produced some exceptional achievements in other centers. Although the production

of the island monastery of Reichenau has been almost entirely lost, there remains the excellent copy of the *Psychomachia* of Prudentius, as mentioned above (Figure V). The neighboring monastery of St. Gall, together with Fulda and Salzburg the most notable of the identifiable East Frankish schools, now added figurative representations to its purely ornamental decorations. The rich illustrations of the Psalms in the most splendid example, the *Psalterium Aureum* (Plates 46–47), are both startling and unique. But in keeping with the character of the St. Gall school, the scenes are stripped of their illusionistic character and transformed into two-dimensional colored drawings—here, too, we may sense that Carolingian illumination was nearing its end.

This becomes evident if we consider the development of the second main group of this time: the Franco-Saxon manuscripts. Around 870, contemporary with that richest of books, the *Codex Aureus* (Plates 35–38), a very different work was produced in the monastery of Saint-Amand for the same patron. This manuscript, the so-called Second Bible of Charles the Bald (Plate 48), gives the impression of being almost a reaction against the world of images represented by the *Codex Aureus*. It marks the apogee and is the purest example of a style that had reached its first bloom in the second quarter of the century, when the monastery of Saint-Bertin had come into prominence with a small group of manuscripts bearing only ornamental decoration. The finest and richest of these was the Psalter (Plate 17) made for Louis the German (840–876).

From the middle of the century onward similar trends in art appeared in various centers, with Saint-Amand playing the leading role. The decoration of Gospels and Sacramentaries—made obviously for export—repeats certain standard series and types of title and initial pages, the finest of which are to be found in the Bible produced for the King. One of the few exceptions to the rule among the Saint-Amand manuscripts is the so-called Gospels of Francis II (Plates 30–31). Here, not only a series of Evangelist portraits is added to the usual decoration, but a miniature of the Crucifixion indicates that these painters were not following the canonical program of a Carolingian Gospel Book, as we know it in other schools.

That such a breach of tradition was possible in the rigidly closed world of Saint-Amand manuscripts can better be understood in the light of the production of other Franco-Saxon monasteries. In Saint-Vaast, for example, less strict rules prevailed. Foliate motifs are combined with the typical ornamental forms of Insular provenance, and even small figures make an appearance in the corners of frames (Arras, Bibliothèque Municipale, Ms. 233). All reserve, however, is thrown to the winds in the most important of these manuscripts, the Prague Gospels (Plates 39–41). At the beginning of each Gospel there are miniatures which, both in extent and subject, are unique among Carolingian

Gospel Books. In these double portraits, where the Evangelist faces a representation of his authorization by Christ or Saint Peter, we have one of the few surviving examples in art showing the struggles over the authenticity of the four Canonical Gospels. That such images, based on a theme that had long since lost all significance, could be produced in a late ninth century manuscript may well be ascribed to the impression created by an outstanding late antique model.

The Prague Gospels is also of exceptional importance on other grounds. We know its history in post-Carolingian times and can trace the influence in Saxony of its initials, its Canon tables, and finally its miniatures from the middle of the tenth into the beginning of the eleventh century. The Prague Gospels is therefore one of the most important testimonies to the role of the Franco-Saxon Schools as Carolingian art was ending. With the fleeing monks, who abandoned their cloisters before the Norman raiders, Franco-Saxon art reached the East, where it survived into the next century. This was possible because its ornamental linear style was not affected by the breakdown of the Carolingian Renaissance schools. Thus it was able to act as a bridge to the beginnings of Ottonian art and to form part of the foundations of a new epoch in the history of manuscript painting.

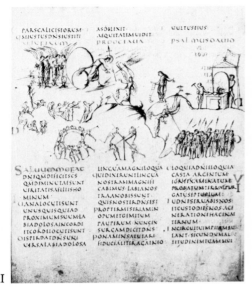

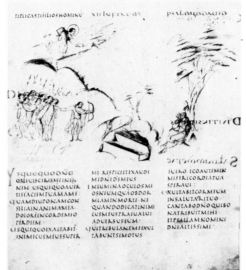

I

II

No biblical book was more popular during the early Middle Ages than the Psalter, whose songs and hymns of lament and plea, of praise and thanksgiving, had not only been made part of liturgy but also offered consolation in private devotion. Many illuminated Psalter manuscripts have survived but none can rival the Utrecht Psalter, which contains the most extensive and the most extraordinary sequence of spirited pen and ink drawings in the history of medieval art.

Some of the drawings present narrative scenes of biblical events; a few others give typological images showing New Testament scenes; most drawings, however, illustrate the poetic text of the Psalms verbally. Thus, for Psalm 11 verse 5: "For the oppression of the poor, for the sighing of the needy, now will I arise saith the Lord . . . ," we see the Lord stepping from his cosmic throne to hand a lance to an angel while the oppressed and needy rise from their dejection to witness the event. In the lower right, the angel rams the end of the lance into the mouth of the first of a group of men whispering to each other. This scene depicts verses 2 and 3: "They speak

vanity everyone with his neighbour: with flattering lips and with a double heart do they speak" and "The Lord shall cut off all flattering lips, and the tongue that speaketh proud things." Above the angel stands the Psalmist himself, holding a scroll and pointing with his left hand toward a smithy. This illustrates verse 6: "The words of the Lord are pure words: as silver tried in a furnace of earth, purified seven times." Finally, in the lower left, men are shown walking around a circular object and pushing a turnstile according to verse 8: "The wicked walk on everyside [the Latin text says *in circuitu* = roundabout], when the vilest men are exalted."

In Psalm 12 the Psalmist beseeches the Lord not to hide his face from him but to "lighten" his eyes "lest I sleep the sleep of death; Lest mine enemy say, I have prevailed against him." The open sarcophagus in the drawing refers to the "sleep of death," the torch in the hand of the Lord sends rays which "lighten" the Psalmist's eyes, and the "enemy" is shown as a group of warriors led by an archer who has raised a threatening bow.

The method of translating the text of the

Psalms by word images was not invented by the draftsmen of the Utrecht Psalter. Though less abundantly used, it is also found in ninth century Byzantine Psalters and a Carolingian one (Stuttgart, Landesbibliothek, bibl. fol. 23). None of their illustrations, however, resemble the drawings of the Utrecht Psalter, whose illusionistic quality recalls the mythological landscapes of Roman wall painting of the first centuries B.C. and A.D., and whose expressive intensity and mobility of figures have no match anywhere save for the miniatures of the Ebo Gospels painted in the same scriptorium (Plates 13, 14).

The verve, dexterity, and seeming spontaneity of Reimsian penmanship on the one hand, and the evident dependence on an older method of illustration on the other, have, time and again, raised the question to what extent the Utrecht Psalter drawings are copies of an earlier source or sources, and to what extent they might be independent accomplishments of the Carolingian artists. While there is no doubt that the draftsmen had access to an illuminated Psalter, the date of this lost exemplar is still debated, as is the question of whether it had illustrated each Psalm in the same breadth and detail within one landscape setting as is the case in the Utrecht Psalter. Among the many hypotheses that have been advanced over the last hundred years of research, one holds that the drawings are more or less faithful copies from an eighth century Greco-Italian Psalter which transmitted a late fourth or early fifth century archetype to the North; another, more recent, places a fifth century manuscript in Carolingian hands, crediting them with some original additions, and with the translation of the model's late antique illusionistic style into the peculiar vibrancy and high-strung expressive force of their drawings. Still, many questions posed by this masterpiece of Carolingian art remain to be answered.

FIGURES III–IV

TERENCE, COMEDIES, fol. 16v: *Illustration to Andria, Act II. Scene 6.*
fol. 67r: *Title page to Heautontimorumenos.*

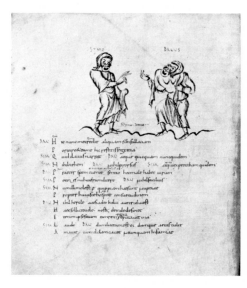

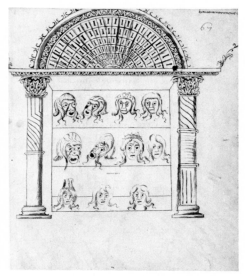

III IV

The plays of Terence survived Antiquity largely because of the purity of their Latin. Quoted even by the Church Fathers, they were much admired during the Middle Ages, as is evidenced by the survival of about a dozen illustrated manuscripts dating from the ninth to the twelfth century. While the earliest copy of about 820 (Rome, Biblioteca Vaticana, vat. lat. 3868) faithfully reproduces the style and painting technique of the miniatures of its fifth century model, the animated pen and ink drawings of this later manuscript from Reims evoke the plays' discourse in a more lively and expressive manner by exaggerating the players' gestures. Here we see the wily Davus as he chides his master Simo with the miserly preparations for the wedding which Simo pretended to have arranged for his son Pamphilus. Each drama is preceded by a title page which displays the masks of the players in an architectural frame, like that for the masks of the eleven characters appearing in *Heautontimorumenos, the Self-Tormentor*.

FIGURE V
PRUDENTIUS, *Psychomachia*, fol. 36r: *Pudicita defeats Libido*.

Embodying the conflict between good and evil in the human soul by battles between personifications of Virtues and Vices, the *Psychomachia* of Prudentius set a theme that was to endure throughout medieval imagery. The allegorical epic had already been illustrated in the fifth century, and this archetype is reflected in various recensions by some sixteen manuscripts dating from the ninth to the thirteenth century.

The Bern codex neither offers the most extensive nor the most accurate copy of the fifth century picture cycle, but its colored drawings are superior to the illustrations of other extant ninth century versions. Although nearly all indications of ground or spatial setting are eliminated, the artist's pen convincingly circumscribed the figures' corporeality and movements. Particularly suggestive is the rendering of the defeated Lust. Hit by a stone flung by Chastity, she has collapsed on her knees, the torches with which she had attacked fallen around her, while the Virtue, clad in late antique armor, bends over to observe the effect of her action before, on the next page, she dispatches the Vice with a sword. The bold foreshortening of the overthrown Lust recalls representations of

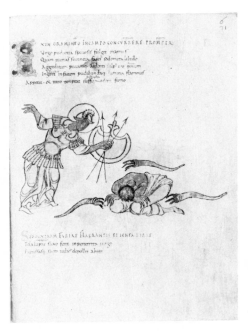

V

fallen warriors in battle scenes on Roman relief sculpture. It must have been derived from a model strongly imbued with reminiscences of antique painting. As the lively drawings of the Utrecht Psalter show many similar foreshortened figures of fallen enemies, as well as other motifs which appear in the Bern *Psychomachia*, it has been

suggested that a Reimsian manuscript might have been available to the artist. If so, he translated the sketchy and impressionistic style of Reims into the contained plastic firmness which distinguishes his work. Such a feat could only have been accomplished by an artist who had formed his own drawing style from examples of late antique art which emphasized clear contours and solidly coherent surfaces.

FIGURE VI
APOCALYPSE, fol. 38r: *The Casting out of the Dragon and his Angels.*

The powerful imagery of Saint John's visions of the cataclysmic events which will precede the final triumph of Christ does not seem to have been translated into a complete picture cycle before the sixth century. The earliest surviving descendents of this cycle are found in four Carolingian Apocalypse manuscripts, none of them produced in a major center of book illumination.

The Trier Apocalypse, as has recently been shown, presents the most faithful reflection of an archetype which, most likely, was created in Rome. The colored drawings of the Trier codex, however, are not slavish copies of their models, just as their distribution on full pages facing the relevant text page seems to have been a Carolingian device. Executed with a robust naiveté — which would have been unacceptable in a luxury manuscript — the drawings impress by their vigor as, for instance, the representation of the war between Michael and his angels, and the dragon with his own, here witnessed by Saint John: "And the great dragon was cast out, that old serpent, called the Devil, and Satan, which deceiveth the whole world: he was cast out into the earth, and his angels were cast out with him." (Revelation 12:7-9). On other pages, the artist exchanged late antique costumes and armor for Frankish ones or went beyond the Apocalypse text by introducing groups of people watching the events.

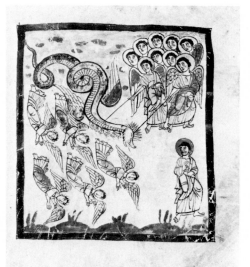

VI

The particular recension of the Trier Apocalypse cycle appears only once more in a later Carolingian manuscript copied after the Trier codex itself (Cambrai, Bibliothèque Municipale, Ms. 386). But the versions of the two other Carolingian manuscripts (Valenciennes, Bibliothèque Municipale, Ms. 99; Paris, Bibliothèque Nationale, Nouv. acq. lat. 1132) feed into Apocalypse illustrations of the eleventh century and beyond. These are indebted to Anglo Saxon intermediaries and possibly connected with the Apocalypse cycle which, according to Bede (673–735), Abbot Benedict Biscop of Wearmouth had brought back from Rome about 672.

Selected Bibliography

General

Braunfels, W., *Die Welt der Karolinger und ihre Kunst,* Munich, 1968.

Hinks, R., *Carolingian Art,* London, 1935, Reprinted Michigan & Toronto, 1962.

Hubert, J., Porcher, J., Volbach, W. F., *The Carolingian Renaissance,* New York, 1970.

Karl der Grosse, Lebenswerk und Nachleben, 4 vols., Düsseldorf, 1965–1967.

Karl der Grosse, Werk und Wirkung [Catalogue of exhibition at Aachen, 1965], Düsseldorf, 1965.

Messerer, W., *Karolingische Kunst,* Cologne, 1973.

Manuscripts

Bischoff, B., "Die Hofbibliothek Karls des Grossen," *Karl der Gross Lebenswerk und Nachleben,* I, Düsseldorf, 1965, pp. 42–62.

Boinet, A., *La Miniature Carolingienne,* Paris, 1913.

DeWald, E., *The Illustrations of the Utrecht Psalter,* Princeton, n.d.

Dufrenne, S., *Les Illustrations du Psautier d'Utrecht. Problèmes des sources et de l'apport carolingien,* Strasbourg (in press).

Engelbrecht, J. H. A., *Het Utrechts Psalterium. Een eeuw wetenschappelijke bestudering (1860–1960),* Utrecht, 1965.

Gaehde, J. E., (Studies on the pictorial sources of the Bible of San Paolo) *Frühmittelalterliche Studien,* V (1971), pp. 359–400; VIII (1974), pp. 351–384; IX (1975), pp. 359–389.

Jones, L. W., and Morey, C. R., *The Miniatures of the Manuscripts of Terence prior to the thirteenth century,* Princeton, n.d.

Kessler, H. L., *The Sources and the Construction of the Genesis, Exodus, Majestas and Apocalypse Frontispiece Illustrations in the ninth-century Touronian Bibles,* Princeton University, PhD, 1965.

Koehler, W., *Die Karolingischen Miniaturen I: Die Schule von Tours,* Vol. 1: *Die Ornamentik,* Berlin, 1930; Vol. 2: *Die Bilder, Berlin,* 1933 [reprinted Berlin, 1963].

Idem, *Die Karolingischen Miniaturen II: Die Hofschule Karls des Grossen,* Berlin, 1958.

Idem, *Die Karolingischen Miniaturen III: Die Gruppe des Wiener Krönungs-Evangeliars — Metzer Handschriften,* Berlin, 1960.

Koehler, W. and Mütherich, F., *Die Karolingischen Miniaturen IV: Die Hofschule Kaiser Lothas — Einzelhandschriften aus Lotharingien,* Berlin, 1971.

Idem, *Die Karolingischen Miniaturen V: Die Hofschule Karls des Kahlen,* Berlin (in preparation).

Koehler, W., *Buchmalerei des frühen Mittelalters, Fragmente und Entwürfe aus dem Nachlass,* eds. E. Kitzinger and F. Mütherich, Munich, 1972.

Merton, A., *Die Buchmalerei in St. Gallen vom 9. bis zum 11. Jahrhundert,* Leipzig, 1912 [2nd ed., 1923].

Mütherich, F., "Die Buchmalerei am Hofe Karls des Grossen," *Karl der Grosse, Lebenswerk und Nachleben,* III, Düsseldorf, 1965, pp. 9–53.

Neumüller, W., and Holter, K., *Der Codex Millenarius* [Forschungen zur Geschichte Oberösterreichs VI], Graz & Cologne, 1959.

Nordenfalk, C., "Book Illumination," *Early Medieval Painting from the fourth to the eleventh century,* Geneva, 1957.

Omont, H., *Bibliothèque Nationale. Reproduction de manuscrits et de miniatures, publiées sous la direction et avec des notices de H. Omont. Bibles de Charles le Chauve,* II., Paris, 1911.

Porcher, J., "La Peinture Provinciale," *Karl der Grosse, Lebenswerk und Nachleben,* III, Düsseldorf, 1965, pp. 54–73.

Rahn, J. R., *Das Psalterium aureum von Sankt Gallen,* ein Beitrag zur *Geschichte der karolinginschen Miniaturmalerei,* St. Gall, 1878.

Stern, H., *Le Calendrier de 354. Étude sur son texte et ses illustrations,* Paris, 1953.

Stettiner, R., *Die illustrierten Prudentius Handschriften,* Berlin, 1895–1905 (2 vols.).

Tselos, D., *The sources of the Utrecht Psalter miniatures,* Minneapolis, 1955 [2nd ed., 1960].

Facsimile editions

Der Codex Aureus der Bayerischen Staatsbibliothek in München, ed. G. Leidinger, Munich, 1921–1925 (6 vols.).

Drogo Sakramentar, Ms. Lat. 9428, Bibliothèque Nationale, Paris, Einleitung F. Mütherich, Graz, 1974.

Hrabanus Maurus, Liber de Laudibus Sanctae Crucis. Vollständige Faksimile-Ausgabe des Codex Vindobonensis 652 der Österr. Nationalbibliothek, Kommentar K. Holter, Graz, 1973.

The Lorsch Gospels, Introduction W. Braunfels, New York, 1967.

Physiologus Bernensis. Voll-Faksimile-Ausgabe des Codex Borgensarius 318 der Burgerbibliothek Bern. Kommentar C. Steiger and O. Homburger, Basel, 1964.

Sakramentar von Metz, Fragment. Ms. Lat. 1141, Bibliothèque Nationale, Paris. Vollständige Faksimile Ausgabe, Einführung F. Mütherich, Graz, 1972.

Der Stuttgarter Bilderpsalter. Bibl. fol. 23. Württembergische Landesbibliothek Stuttgart, I: Faksimile. II: Untersuchüngen, B. Bischoff, B. Fischer, F. Mütherich, et al, Stuttgart, 1968.

Trierer Apokalypse, Vollständige Faksimile Ausgabe im Originalformat des Codex 31 der Stadtbibliothek Trier, I: Faksimile. II: Kommentar R. Laufner and P. Klein, Graz, 1972.

Provenances of Manuscripts

Color Plates

I. GODESCALC EVANGELISTARY

Court School of Charlemagne; between
781 and 783
Paris, Bibliothèque Nationale, Nouv.
acq. lat. 1203
127 fols. 310 x 210 mm

The manuscript is a Gospel Lectionary containing the sections from the Gospels (Pericopes) read at Mass during the liturgical year. A dedicatory poem indicates it was made at the command of King Charles and his wife Hildegarde by the scribe Godescalc.

The text is written with gold and silver ink on purple-colored parchment: the liturgical part in uncial letters and capital letters for headings, the dedicatory poem introducing the minuscule script then newly adopted and perfected at the Carolingian court. The two text columns on all pages are enclosed by ornamental frames. Further decoration consists of initials opening the most important readings and six full-page miniatures at the beginning: portraits of the four Evangelists (fols. 1r–2v), of Christ (fol. 3r), and an image of the Fountain of Life (fol. 3v).

In the Middle Ages, the manuscript was kept at Saint Sernin in Toulouse. It was deposited in the museum at Toulouse during the French Revolution, added to the collection of Napoleon in 1811, and finally given to the Bibliothèque Nationale in 1872.

Plate 1. *Christ, fol. 3r*
Plate 2. *Fountain of Life, fol. 3v*
Plate 3. *Initial Page to the Vigil for Christmas, fol. 4r*

II. GOSPELS OF SAINT MÉDARD OF SOISSONS

Court School of Charlemagne; early
ninth century

Paris, Bibliothèque Nationale, lat. 8850
239 fols. 362 x 267 mm
(severely cut)

The Gospels and their prologues are written in uncial script with gold ink on uncolored parchment. Headings are set off by capital letters. The pages have two text columns enclosed by ornamental frames. The chapter list (fols. 223r–239v) is written in gold minuscule and has no frames. The decoration consists of twelve Canon Tables (fols. 7r–12v) and six miniatures: the Adoration of the Lamb (fol. 1v), the Fountain of Life (fol. 6v), and four Evangelist portraits (fols. 17v, 81v, 123v, 180v). Each Evangelist portrait is faced by an ornate initial page on recto. The initial pages to Mark, Luke, and John also contain figurative images.

According to a text of 930, the manuscript was given by Louis the Pious and his wife Judith to the church of Saint Médard of Soissons on Easter, 827. After 1790 it was brought to Paris, and in the nineteenth century it entered the Bibliothèque Nationale.

Plate 4. *The Adoration of the Lamb, fol. 1v*
Plate 5. *Canon Table, fol. 7v*
Plate 6. *Saint Mark, fol. 81v*
Plate 7. *Initial to the Gospel of Saint Mark, fol. 82r*

III. CORONATION GOSPELS

Court of Charlemagne; late eighth
century
Vienna, Weltliche Schatzkammer
236 fols. 324 x 249 mm (upper
margin cut)

The parchment leaves are colored purple and carry one column of writing in gold in the manner of late antique luxury manuscripts. The Gospel text is executed in uncial script, the *Incipits,* prefaces, prologues, and chapter list in rustic capitals.

Silver ink is used for page headings and for all *Incipits* except those of the Gospels. The name *Demetrius Presbyter* is entered in gold rustic capitals on the margin of fol. 118r. The decoration consists of sixteen Canon Tables (fols. 7r–14v), four Evangelist portraits (fols. 15r, 76r, 117v, 178v), and four modestly sized initials on the pages beginning each Gospel text (fols. 16r, 77r, 118r, 179r).

Tradition has it that the German Emperor Otto III found the manuscript when he opened the tomb of Charlemagne at Aachen in the year 1000. The German Emperors swore their coronation oaths on this codex, which had become part of the treasure of imperial insignia. It was removed from Aachen during the revolutionary wars and brought to Vienna in 1811.

Plate 8. *Saint Mark, fol. 76v*
Plate 9. *Beginning of Saint Mark's Gospel, fol. 77r*
Plate 10. *Saint John, fol. 178v*

IV. GOSPELS

Fleury; ca. 820
Bern, Burgerbibliothek, Cod. 348
219 fols. 248 x 198 mm

The Gospels are written with brown ink in minuscule script. Uncials, capitals, and rustic capitals are used for *Incipits,* headings, etc., without systematic order. The decoration consists of fifteen Canon Tables (fols. 1r–8r) and one miniature depicting the Hand of God and the four Evangelist symbols (fol. 8v).

The history of the manuscript is unknown until the later sixteenth century when it belonged to the French collector J. Bongars (1554–1612), whose heirs brought it to Bern in the seventeenth century.

Plate 11. *Hand of God and Symbols of the Four Evangelists, fol. 8v*

V. HRABANUS MAURUS, DE LAUDIBUS SANCTAE CRUCIS

Fulda; ca. 840
Rome, Bibliotheca Vaticana, Reg.
lat. 124
61 fols. 365 x 295 mm

Hrabanus, a pupil of Alcuin of Tours, later Abbot of Fulda (822–842) and Archbishop of Mainz (847–856), wrote among many other works a tract, *In Praise of the Holy Cross,* of which dedication copies were made for Louis the Pious, Pope Gregory IV, the Archbishop of Mainz, and other. The Vatican codex is the oldest of the existent copies of one of these lost luxury editions. It contains seven colored miniatures: the Dedication of the work to Saint Martin of Tours (fol. 2v) and to Pope Gregory IV (fol. 3v), a portrait of Louis the Pious (fol. 4v), and images of the crucified Christ (fol. 8v), the Seraphim and Cherubim (fol. 11v), the Lamb of God (fol. 22v), and Hrabanus kneeling before the Cross (fol. 35v).

Plate 12. *Portrait of Louis the Pious,*
 fol. 4v

VI. EBO GOSPELS

Reims; between 816 and 835
Épernay, Bibliothèque Municipale,
Ms. 1
178 fols. 260 x 149 mm

The first leaf of this Gospel Book contains a dedicatory poem in which Peter, Abbot of the monastery of Hautvillers near Reims, praises the achievements of the patron and donor Archbishop Ebo of Reims.

The poem is written in gold rustic capitals, and the Gospel text in gold minuscule. The decoration consists of twelve Canon Tables (fols. 10r–15v), and four Evangelist portraits (fols. 18v, 60v, 90v, 125v) each faced by an initial page on recto.

The manuscript remained at Hautvillers until the French Revolution, when it was deposited in the Municipal Library at Épernay.

Plate 13. *Canon Table, fol. 13r*
Plate 14. *Saint Matthew, fol. 18v*
Plate 15. *Initial Page to the Gospel of*
 Saint Matthew, fol. 19r

VII. PHYSIOLOGUS

Reims; second quarter of the ninth
century
Bern, Burgerbibliothek, Cod. 318
131 fols. 255 x 175.5 mm

Among other texts, the codex contains the oldest surviving illustrated Latin edition of the *Physiologus,* a Greek work describing and interpreting the habits and properties of real or mythical beasts, plants, and stones in terms of Christian allegory.

The manuscript is written in minuscule with headings in uncial script. The name of the scribe, Haecpertus, is entered on fol. 125r. The *Physiologus* text (fols. 7r–22v) is accompanied by twenty-five framed and ten unframed miniatures.

In the possession of a Reimsian family during the early fifteenth century, the codex passed into the collection of J. Bongars (1554–1612) before being brought to Bern in the seventeenth century.

Plate 16. *On the Fourth Nature of the*
 Serpent and on the First and
 Second Nature of the Ants,
 fol. 12v

VIII. PSALTER OF KING LOUIS

Saint Omer; second quarter of the
ninth century
Berlin, Stiftung Preussischer
Kulturbesitz, Staatsbibiothek,
Theol. lat. fol. 58
120 fols. 294 x 246 mm

The manuscript is dedicated to a King Louis (fols. 1v–2r) who, in the light of the advanced style of the work's script and decoration, can be identified as Louis the German (840–876).

All pages are enclosed by ornamental frames, each corresponding in pattern to the facing one. Initials mark the beginning of each psalm with the following verse or verses written in gold uncials and the remainder in minuscule on two columns. Psalms 1, 10, 51, 60, 70, 80, 101, and 109 are distinguished by larger initials, and Psalms 1 and 101 are preceded by a decorative *Incipit* page.

Later Carolingian additions at the end of the codex consist of an *Oratio ante crucem dicenda* with the representation of a man praying before a cross, and three poems with neumes from *De consolatione philosophiae* by Boethius.

Owners' entries on fol. 1v place the manuscript in Rhineland-Westfalia during the sixteenth century.

Plate 17. *Beginning to Psalm I, fol. 3r*

IX. ARATEA

Lorraine; second quarter of the ninth
century
Leiden, Bibliotheek der
Rijksuniversiteit, Voss. lat. Q 79
99 fols. (losses); 225 x 200 mm

A luxury edition of the work *Phaino-mena* on the celestial constellations by the Greek poet Aratos (315–245 B.C.) in the Latin translation of Germanicus Caesar (15 B.C.–19 A.D.), with some additions from the later one by Avienus (mid-fourth century).

Thirty-eight miniatures of constellations and one planisphere on the verso of otherwise blank leaves are accompanied by the text written in rustic capitals on intermittent leaves.

The manuscript was twice copied at Saint Bertin in northern France during the early eleventh century. In 1573 it was acquired by Jacob Susius of Ghent and later was owned by Hugo Grotius, who had the miniatures used as models for his *Syntagma Arateorum,* Leiden, 1600. Subsequently part of the Library of Queen Christine of Sweden, it came into the possession of Isaak Vossius and was given with his collection to the Rijksuniversiteit, Leiden.

Plate 18. *Cepheus, fol. 26v*
Plate 19. *Pleiades, fol. 42v*

X. GRANDVAL BIBLE

Tours; ca. 840
London, British Museum, Add.
Ms. 10 546
449 fols. 375 x 510 mm

One of the two earliest preserved illustrated Carolingian Bible manuscripts, the Grandval Bible contains four full-page miniatures: scenes from Genesis (fol. 5r), Moses receiving and transmitting the Law (fol. 25v), Christ in Majesty (fol. 352v), and a representation to Revelation (fol. 449r). The text is written in minuscule on two columns. Further decoration consists of a framed *Incipit* page to the letter of

Saint Jerome to Paulinus on the New and Old Testaments (fol. 1v), fifty-five initials in gold, silver, and colors, and four Canon Tables (fols. 349v–351r).

During the end of the sixteenth century, the Bible was in possession of the Abbey of Moutier-Grandval in Switzerland. In private ownership after 1792, it was acquired by de Speyr-Passavant, who sold it to the British Museum in 1836.

XI. VIVIAN BIBLE [So-called First
 Bible of Charles the Bald]
 Tours; 845–846
 Paris, Bibliothèque Nationale, lat. 1
 423 fols. 495 x 345 mm

The last of three dedicatory poems (fols. 1r–2v, 329r, 422r) establishes that this Bible was dedicated to Charles the Bald by the Lay-Abbot, Count Vivian (844–851), and the monks of Saint Martin's of Tours upon the occasion of Charles's confirmation of the Abbey's rights of immunity in 845. The presentation of the Bible itself probably took place in 846 and is depicted on fol. 422v.

The text is written in minuscule on two columns. The poems, headings, etc., are distinguished by golden rustic capitals. The decoration consists of eighty-seven initials of varying size in gold, silver, and colors; thirteen pages with ornamental frames for the dedicatory poems, one *Incipit,* three prefaces, the chapter index to Genesis, first-text pages of three biblical books, and the concordance of the Pauline epistles, four Canon Tables, and eight full-page miniatures: Saint Jerome as the Translator of the Bible (fol. 3v), Scenes from Genesis (fol. 10v), Moses receiving and transmitting the Law (fol. 27v), David as the Composer of the Psalms (fol. 215v), Christ in Majesty (fol. 329v), the Conversion of Saint Paul (fol. 386v), a representation to Revelation (fol. 415v), and Presentation of the Bible to Charles the Bald (fol. 422v).

Probably donated by Charles the Bald to the Cathedral of Metz in 869–870, the manuscript remained there until 1675 when it was given to Colbert, Minister of Finance to Louis XIV. It was later transferred to the Royal Collection and finally to the Bibliothèque Nationale.

XII. LOTHAIR GOSPELS
 Tours; between 849 and 851
 Paris, Bibliothèque Nationale,
 lat. 266
 221 fols. 250 x 322 mm

According to its dedicatory poem (fol. 2r), the manuscript was produced at the order of the Emperor Lothair I. As Tours belonged to the kingdom of Charles the Bald, the codex must date after the reconciliation of Charles and his half-brother Lothair in January 849, and before the death of Lothair's wife Hermingard in 851, because she is mentioned in the poem.

This luxury edition is written entirely in gold: the Gospel text in half-uncials followed by minuscule; headings and prefatory materials in capitals, rustic capitals, and uncials. The decoration consists of nine framed *Incipit* pages, twelve Canon Tables, eighteen framed chapter indices, five initials, and six miniatures depicting: Lothair enthroned (fol. 1v), Christ in Majesty (fol. 2r), and four Evangelist portraits (fols. 22v, 75v, 112v, 171v).

In 1367, the manuscript seems to have been in the monastery of Pontfroid near Metz. At the beginning of the 16th century, it belonged to the Royal Library at Blois.

XIII. ASTRONOMICAL–
 COMPUTISTIC MANUAL
 Metz; ca. 840
 Madrid, Biblioteca Nacional,
 Cod. 3307
 76 fols. 300 x 238 mm

An incomplete copy of a work compiled in 810 at the court of Charlemagne from excerpts of Pliny, Hyginus, Isidore, and Bede. Written in minuscule, the manuscript contains forty-one illustrations of the constellations and four schemata relating to their positions and movements.

At the Abbey of Prüm toward the end of the ninth century, the manuscript was transferred to the Diocese of Liège about 922. In 1543, it was owned by Franciscus Monachi, a Minorite from Spanish Sicily.

XIV. DROGO SACRAMENTARY
 Metz; between 850 and 855
 Paris, Bibliothèque Nationale,
 lat. 9428
 130 fols. 264 x 214 mm

The Sacramentary contains the prayers recited by the celebrant at Solemn Mass. Preceded by formulae for the consecration of priests and by general prayers, the main body of the manuscript consists of the Mass Canon and prayers for the celebration of Mass during the liturgical year. The text follows that of the Sacramentary that Charlemagne had requested and received from Pope Hadrian I, in 785 or 786, but with supplements compiled by Alcuin. Additions show that the book was made for the use of the Cathedral of Metz, undoubtedly on commission of Archbishop Drogo (844–855), whose name appears in golden uncials at the end of a list of the Bishops of Metz.

The entire manuscript is written in gold, with capitals, rustic capitals, and uncials distinguishing separate sections. Among its rich decoration with initials, framed pages, or framed parts of pages, the most important are the forty-one historiated initials whose figures or scenes illustrate, in most instances, the content of the following Mass Pericopes.

The Drogo Sacramentary remained in the Treasury of Metz Cathedral until it was brought to Paris in 1802.

XV. GOSPELS [So-called Gospel Book
 of Francis II]
 Saint Amand; second half of the
 ninth century
 Paris, Bibliothèque Nationale,
 lat. 257
 200 fols. 300 x 255 mm

The Gospel text is written in minuscule, with chapter headings in uncials. The decoration consists of twelve Canon Tables (fols. 6v–12r), four *Incipit* pages in golden capital letters (fols. 13v, 61v, 95v, 148v), five full-page initials in gold and silver framed by arches (fols. 1r, 14r, 62r, 96r, 149r), and five miniatures representing: the Crucifixion (fol. 12v) and the four Evangelists (fols. 13r, 60v, 94v, 147v). The portraits of Saints Mark, Luke, and John are faced on recto by pages containing their symbols in a medallion enclosed by an arch identical to that enframing the Evangelist.

The leather binding shows the coat of arms of either Francis I or Francis II.

Plate 30. *Saint John,* fol. 147v
Plate 31. *Symbol of Saint John,*
fol. 148r

XVI. SACRAMENTARY FRAGMENT FROM METZ
Court School of Charles the Bald; ca. 870
Paris, Bibliothèque Nationale, lat. 1141
10 fols. 270 x 210 mm

Intended to be a complete Sacramentary, the manuscript remained unfinished and contains only an abbreviated Mass Order, the Solemn Prayer (*Prefatio*), and the prayers of the Mass Canon.

The first three pages containing the title and Mass Order are written in alternating lines of gold, green, and red capital letters on blank parchment (fols. 1r–2r). All subsequent pages are richly framed. The beginning of the *Prefatio* shows gold capital letters on purple bands which are separated by alternating green and blue bands (fol. 3v), while the first page of the Canon is written in gold uncials (fol. 7r), with the following ones in gold minuscule. First letters of sections or important names are placed on small purple fields. Further decoration consists of one ornamental full-page initial (fol. 4r) and another one with the image of the crucified Christ (fol. 6v), as well as five miniatures: a standing Carolingian ruler flanked by two bishops and crowned by the hand of God (fol. 2v), Saint Gregory inspired by the Holy Ghost (fol. 3r), Christ in Majesty with the angelic choir and a Seraphim (fol. 5r), the Heavenly Hierarchy

(fol. 5v), Christ in Majesty with Seraphim and personifications of *Terra* and *Oceanus* (fol. 6r).

The early history of the manuscript fragment is unknown. In 1732 it was acquired from the estate of Colbert for the Royal Collection.

Plate 32. *Saint Gregory,* fol. 3r
Plate 33. *Christ in Majesty,* fol. 5r
Plate 34. *Initial: Te Igitur—Christ Crucified,* fol. 6v

XVII. CODEX AUREUS OF SAINT EMMERAM
Court School of Charles the Bald; 870
Munich, Bayerische Staatsbibliothek, Clm. 14000
126 fols. 420 x 330 mm
(margins cut)

Written for Charles the Bald by the brothers Beringar and Liuthard, the manuscript contains the four Gospels with their prologues and prefaces as well as three dedicatory poems (fols. 5v, 97v, 126r), the last one giving the date and the names of the scribes.

Frames enclose each page and column of the text which is written in gold uncials. The patterns of each facing frame correspond. In addition to twelve Canon Tables (fols. 7r–12v) and many single initials, the codex contains ten ornamental *Incipit* and initial pages, two at the beginning (fols. 1v, 2r) and two facing each other before each of the four Gospels (fols. 16v & 17r, 46v & 47r, 65v & 66r, 97v & 98r). These pages are preceded by the Evangelist portraits (fols. 16r, 46r, 65r, 97r). Three more miniatures stand at the beginning of the manuscript: the Throne Effigy of Charles the Bald (fol. 5v), the Adoration of the Lamb (fol. 6r), and Christ in Majesty (fol. 6v).

According to eleventh century documents, the manuscript was given ca. 893 to the Abbey of Saint Emmeram at Ratisbon by Emperor Arnulf. A later miniature and inscription on the originally blank page fol. 1r says that the codex and its cover were restored during the period of Abbot Ramwold (979–1001).

Plate 35. *Saint Matthew,* fol. 16r
Plate 36. *Incipit page to the Gospel of Saint Matthew,* fol. 16v

Plate 37. *Throne Effigy of Charles the Bald,* fol. 5v
Plate 38. *The Adoration of the Lamb,* fol. 6r

XVIII. GOSPELS
Saint-Vaast; late ninth century
Prague, Kapitulni Knihovna, Cim. 2
244 fols. 348 x 255 mm

The Gospel text is written in uncial script with brown ink. The decoration consists of fifteen Canon Tables (fols. 7v–14v) and two facing miniatures for each Gospel representing on verso the Calling of the Evangelist, and on recto the author portrait of the Evangelist (fols. 23v–24r, 82v–83r, 125v–126r, 185v–186r). The miniatures are followed by facing framed *Incipit* and initial pages. The *Incipits* are written in gold capital letters and the intervals between the lines are decorated with mostly vegetal ornament. The initials are executed in gold and colors (fols. 24v–25r, 83v–84r, 126v–127r, 186v–187r). The first two pages of the Gospel text are written in silver on framed purple fields (fols. 25v–26r, 84v–85r, 127v–128r, 187v–188r).

Plate 39. *The Calling of Saint Matthew,* fol. 23v
Plate 40. *Saint Matthew,* fol. 24r
Plate 41. *Initial to the Gospel of Saint Luke,* fol. 127r

XIX. BIBLE OF SAN PAOLO FUORI LE MURA
Reims (?); ca. 870
Rome, Abbazia di San Paolo f.l.m.
337 fols. (without two seventeenth century fly-leaves);
448 x 355 mm (margins trimmed)
[The Roman folio numbers in parentheses refer to a fourteenth century collation; the Arabic folio numbers follow a recent pagination.]

A dedicatory prologue by Ingobertus, *referens et scriba fidelis* (fols. 2v–3[vi]r), and verses accompanying a throne effigy (fol. 1r[cccxxxiiii]v) establish that the Bible was made for a King Charles who has been recognized as Charles the Bald. The date of the manuscript before or after

870 depends on the identity of the Queen standing next to the King on the throne effigy, who has been thought to represent either his first wife Hermintrude who died on October 6, 869, or his second wife Richildis whom he married on January 22, 870.

The dedicatory prologue is written in gold rustic capitals and enclosed by frames, and the text with brown ink in minuscule. The *Incipits* and *Explicits* of prefaces, chapter summaries, and biblical books are executed in capital letters, the lines alternatingly gold and red. Rustic capitals and uncials are used for special passages and first letters of verses. The major decoration of the Bible consists of one framed ornamental *Incipit* page (fol. 9 [viii]v) and ninety-one rich initials, of which thiry-six occupy a full page. Besides four Canon Tables (fols. 257[ccliiii]r–258[cclv]v), the manuscript now contains twenty-four frontispiece miniatures: Prefaces of Saint Jerome (fol. 3[vi]v), Genesis (fol. 8[vii]v), Exodus (fol. 21[xx]v), Leviticus [Moses receiving and transmitting the Law] (fol. 31[xxx]v), Leviticus (fol. 32[xxxi]v), Numbers (fol. 40[xxxviiii]v), Deuteronomy (fol. 50[xlviiii]v), Joshua (fol. 59 [lviii]v), Kings I (fol. 83[lxxxi]v), Kings II (fol. 93[lxxxxi]r), Prophets (fol. 117 [cxv]v), Psalms (fol. 170 [clxvii]v), Proverbs (fol. 188[clxxxv]v), Judith (fol. 234[ccxxxi]v), Maccabees (fol. 243 [ccxxxx]v), Christ in Majesty (fol. 259 [cclvi]v), 4 Evangelist portraits (fols. 260 [cclvii]v), 270[cclxvii]r), 277[cclxxiiii] r), 287[cclxxxiiii]v), Acts (fol. 295[cclxxxii]v), Epistles of Saint Paul (fol. 310 [cccvii]v), Apocalypse (fol. 331[cccxxviii] v), Throne effigy of Charles the Bald (fol. 1r[cccxxxiiii]v).

The manuscript's presence in Italy during the late eleventh century is attested by a contemporary entry on the blank recto of fol. 2 of the oath of fealty by the Norman Duke Robert Guiscard to Pope Gregory VII in 1080. It is most likely, however, that the Bible was one of the gifts of Charles the Bald to Pope John VIII on the occasion of his coronation in Rome as Emperor in 875.

Plate 42. *Initial page to Genesis,* fol. 10 (viiii)r
Plate 43. *Frontispiece to Deuteronomy,* fol. 50(xlviiii)v
Plate 44. *Frontispiece to Proverbs,* fol. 188 (clxxxv)v
Plate 45. *Frontispiece to Apocalypse,* fol. 331 (cccxxviii)v

XX. PSALTERIUM AUREUM

Saint-Gall; second half of the ninth century (before 883)
Saint-Gall, Stiftsbibliothek, Cod. 22
344 pages 363 x 265 mm

The manuscript is written in gold half-uncials on one column per page. Its decoration consists of thirty-four initials of medium to small size betraying a variety of stylistic impulses. Three large initials to Psalms 1, 41, and 72 reflect the first three sections of the five-partite division of the Hebraic version of the Psalter. They are executed in gold and colors. The initials to Psalms 1 and 72 are framed (pp. 17, 171), that to Psalm 41 is without frame (p. 99). Two full-page miniatures at the beginning of the Psalter depict within an architectural framework David composing the Psalms, accompanied by two musicians and two dancers (p. 2), and Saint Jerome holding a book and blessing (p. 14). Fifteen illustrations to the Psalm titles are sporadically distributed and occupy either a whole or, more often, half a page (pp. 39, 59, 63, 64, 66, 75, 122, 132, 136, 139, 140, 141, 147, 150, 160). There are no illustrations after Psalm 72.

Plate 46. *Illustration to Psalm 59: The Campaign of Joab,* p. 140
Plate 47. *Illustration to Psalm 59: Assault on two Cities,* p. 141

XXI. BIBLE OF CHARLES THE BALD

[So-called Second Bible of Charles the Bald]
Saint Amand; between 871 and 873
Paris, Bibliothèque Nationale, lat. 2
444 fols. 430 x 335 mm

According to its dedicatory poem, the Bible was written for Charles the Bald. Mention of Charles's pardon of a "cruel tyrant" refers to his rebellious son Carloman, Abbot of Saint Amand from 867 to 871, and dates the manuscript after 871 and before 873, when new disaffections caused the King to have his son blinded.

Although without figurative illustrations, the manuscript is splendidly illuminated by two framed initial pages at the beginning of Genesis (fols. 10v, 11r), six Canon Tables (fols. 351v–354r), and seventy-

four large initials in gold and color, opening the text of the biblical books.

Bequeathed by Charles to the Abbey of Saint Denis, the Bible remained there until it passed into the Royal Library in 1595.

Plate 48. *Initial to Genesis,* fol. 11r

Black-and-White Figures

A. UTRECHT PSALTER

Reims; between 816 and 835
Utrecht, Bibliotheek der Rijksuniversiteit, Cat. Cod. Ms. Bibl. Rhenotraiectinae, I, Nr. 32
108 fols. 335 x 260 mm

The manuscript contains the whole Psalter in the Gallican version of Saint Jerome, Old and New Testament Canticles, the Pater Noster and Symbolum Apostolorum.

The text is written in brown ink rustic capitals. There is only one initial to Psalm I. Each of the Psalms, Canticles and Creeds is preceded by pen drawings in brown ink, most of which translate the text into literal or word images.

About the year 1000, the Psalter was brought to England where it was copied three times (London, British Museum, Harley 603, early eleventh century; Cambridge, Trinity College, Ms. R. 17, ca. 1150; Paris, Bibliothèque Nationale, Lat. 8846, ca. 1200). After the dissolution of the English monasteries it came into private hands, the last being Sir Robert Cotton (1571–1631). Nothing is known of the manuscript's fate between 1631 and 1716 when it was presented to the city of Utrecht.

Figure I. *Illustration to Psalm 11,* fol. 6v
Figure II. *Illustration to Psalm 12,* fol. 7r

B. TERENCE, COMEDIES

Reims; second half of the ninth century
Paris, Bibliothèque Nationale, Lat. 7899
176 fols. 260 x 215 mm

The manuscript contains the comedies *Andria, Eunuchus, Heautontimorumenos, Adelphi, Hecyra,* and *Phormio* in the edition attributed to Calliopius. The text is written in brown minuscule on one column with headings, etc. in red rustic capitals. One hundred and forty-eight pen and ink drawings depicting scenes of the plays are interspersed throughout the text. A portrait of Terence appears on fol. 2r.

A thirteenth century library mark on fol. 3r and an entry on fol. 41r indicate that the manuscript belonged to the Abbey of Saint Denis where it remained until 1595.

Figure III. *Illustration to Andria, Act II, Scene 6,* fol. 16v

Figure IV. *Title page to Heautontimorumenos,* fol. 67r

The Vulgate text of the Apocalypse always occupies one page and its illustrations with framed, colored pen-drawings, another. Twenty pictures (until fol. 20) are on recto, the following fifty-four always on verso, so that text and image face each other. The artificial half-uncial script suggests a place of origin under the influence of Tours.

Extensive text correction during the eleventh century revised the order of the chapters. At that time, the manuscript is likely to have been in the possession of the monastery of St. Eustachius at Trier, although the monastery's oldest library entries in the codex date into the twelfth century.

Figure VI. *The Casting out of the Dragon and his Angels* (Revelation 12:7–9), fol. 38r

C. PRUDENTIUS, POEMS
Reichenau (?); last third of the ninth century
Bern, Burgerbibliothek, Cod. 264
145 fols. 273/283 x 215/220 mm

A luxury edition written in brown minuscule and decorated with numerous initials, the manuscript contains a collection of the works of the Christian poet Prudentius (ca. 348–410). Though incomplete, three of these are illustrated: the Cathemerinon (twelve hymns for daily use and festivals), fols. 2v–4v; the *Psychomachia* (an allegory of the struggle between the Virtues and Vices), fols. 31r–45v, with an author portrait on fol. 34r; and the *Peristephanon* (fourteen hymns to maryrs), fols. 60r–75r.

The manuscript belonged to the library of the Cathedral of Strasbourg from the thirteenth to the fifteenth century. At the beginning of the seventeenth century it was acquired from Count Frederic Casimir of Pfalz-Zweibrucken by J. Bongars, whose heirs brought it to Bern.

Figure V. *Psychomachia: Pucidita defeats Libido,* fol. 36r

D. APOCALYPSE
France; first quarter of the ninth century
Trier, Stadtbibiothek, Cod. 31
74 fols. 262 x 216 mm

Plates and
Commentaries

PLATE 1
GODESCALC EVANGELISTARY, fol. 3r: *Christ*

The immobile frontality of the enthroned blessing Christ is very striking, especially in contrast to the preceding pages in the manuscript which portray the four Evangelists in different attitudes, pausing in their writing to draw inspiration from their symbols. With the image of Christ, the illuminator had less of a problem in reconciling his attachment to two-dimensional expression with a rendering of figures in varied movements, a problem not entirely resolved in the Evangelist pages. The miniature of Christ forms a consistent pattern of lines and sonorous colors. Vestiges of landscape and architecture join with purely ornamental fields, lettering, and frame, into a carpet-like ground from which the figure is set off by its contours, by the formalized lines of mantle and tunic, and, above all, by the luminous flesh tones of head, hands, and feet which are given substance by modeling with light and shade.

Such corporeal presence was new to the Carolingian North and, like the haunting stare, reveals the painter's debt to Italy and Byzantium. During his sojourn in Italy, Charlemagne might have acquired a manuscript whose miniatures were to serve as models for later work. The provenance and date of this manuscript remain a matter of conjecture. The softly rounded face and large eyes of the Godescalc Christ, already familiar from sixth century ivory carvings, as well as from mosaics at Ravenna, are also found in eighth century Italian frescoes dependent on Byzantine influence. It is therefore likely that the Carolingian artist received his inspiration from a tradition then still alive beyond the Alps. Nevertheless, the model must have presented him with an extraordinary challenge. Unaccustomed to Mediterranean figure art, he strove to master its lessons, which he fused with his native taste for ornament and pattern to create a work worthy of his patron and a portent of the future ambitions and successes of the Court School of Charlemagne.

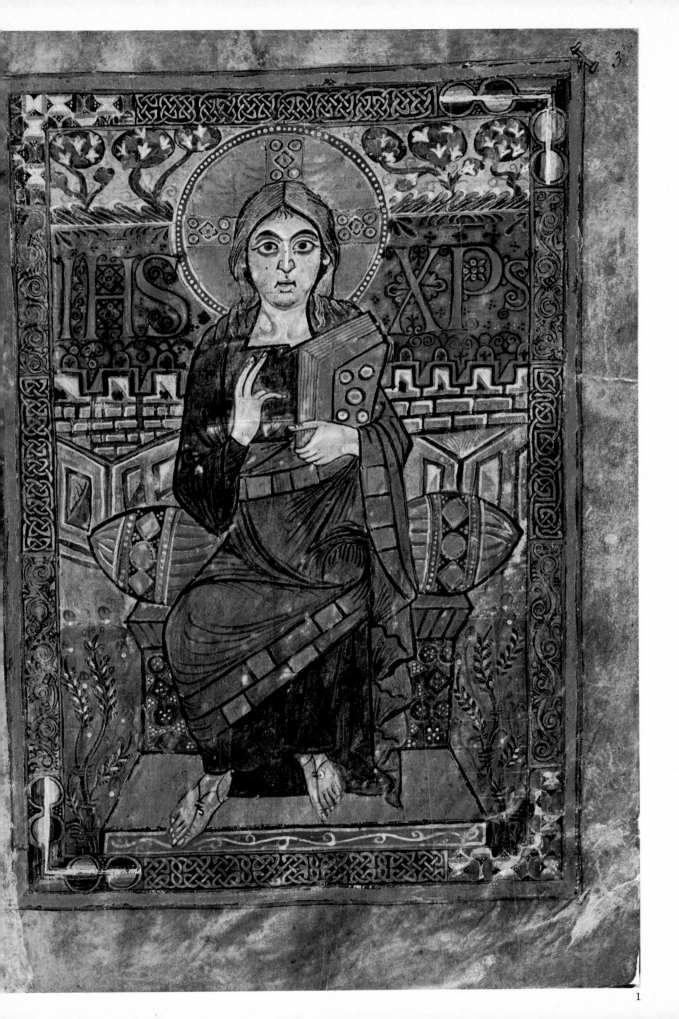

PLATE 2
GODESCALC EVANGELISTARY, fol. 3v: *Fountain of Life*

The rare theme of the Fountain of Life, appearing here for the first time in Carolingian art, is related to baptism and has therefore been thought to allude to the actual font in the Lateran baptistry in Rome where Charlemagne's son was likely to have been baptized. The origin of images of the Fountain of Life in manuscript illumination is, however, much older. Although only surviving in Eastern manuscripts, it was a symbol of the Gospels, as the font of eternal life, and was thus placed with the sequence of Canon Tables which correlate all shared and differing passages of the four Gospels according to a system devised between 314 and 331 by Eusebius, Bishop of Cesarea in Palestine.

This original meaning is modified in the Godescalc Evangelistary. The Fountain of Life is set in relation to the facing page by corresponding frames and by the gold lettering above its roof which gives the heading [*Incipit*] of the Christmas Pericope (Matthew 1:18–21) initiated to the right (Plate 3). Referring to Christ's birth as the Fountain of Life, these pages complement each other. Birds of recognizable species but with old paradisiacal connotations, and a stag, standing for mankind thirsting for the water of salvation (Psalm 42), surround the image of the Fountain. With it they form a flat but colorful pattern, whereas the pattern of initial, letter, and ornament has become the abstract equivalent of an image.

The juxtaposition of the two pages is perhaps so successful because the painter of the Fountain of Life disregarded nearly all those vestiges of spatial depth which his model is sure to have preserved. A later artist of the Court School of Charlemagne appreciated and adapted these aspects more thoroughly when he painted the only other preserved full-page image of the Fountain of Life in the Gospels of Saint Médard of Soissons. (For other miniatures of this manuscript see Plates 4–7.)

PLATE 3
GODESCALC EVANGELISTARY, fol. 4r: *Initial Page to the Vigil for Christmas*

Gold, silver (now blackened by oxidation), and bright colors on purple are no mere token of ostentation. In his poem, Godescalc draws the analogy between such splendor and eternal life, just as another scribe of the Court School, Dagulf, saw in golden letters the golden words which promise the golden kingdom. Precious materials were believed to be gifts of God in the Middle Ages, but in order to truly illuminate His truth, they had to be refined and worked with skill and artifice.

The skill of the master of this page was sharpened by the study of works from two very different worlds: the clear capital lettering of the late Roman antique, transmitted from Italy, and the intricately interlaced initial letters and pages of Hiberno-Saxon manuscripts, which Irish and Anglo-Saxon missionaries had brought to the continent. The great initial connecting the letters *I* and *N* in a ligature beginning the words *In illo tempore* has clearly been influenced by Insular work. But the kinetic energy which the tradition of Celtic and Germanic metalwork had imparted to Hiberno-Saxon manuscript illumination has been tamed here. The initial is made to respect the order of the frame; the movement of the connecting skeins of thin golden interlace at the letters crowns and tails is concentric more than eccentric; and most of the ornamental motifs in and between the stems of the initial letters—the meander, step-pattern, palmette, and lozenge—are of Mediterranean origin. Thus, there is no discord between the left field of the page and the right one with its measured lines of alternating gold and silver capitals interspersed with calligraphic flourishes. Two disparate traditions are joined here in a new statement of solemn magnificence.

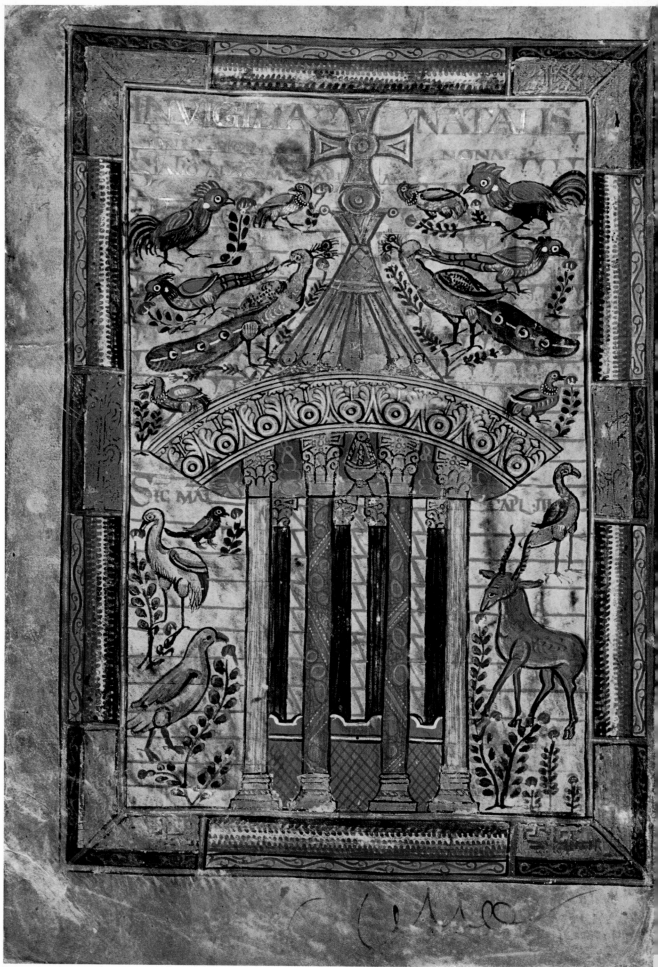

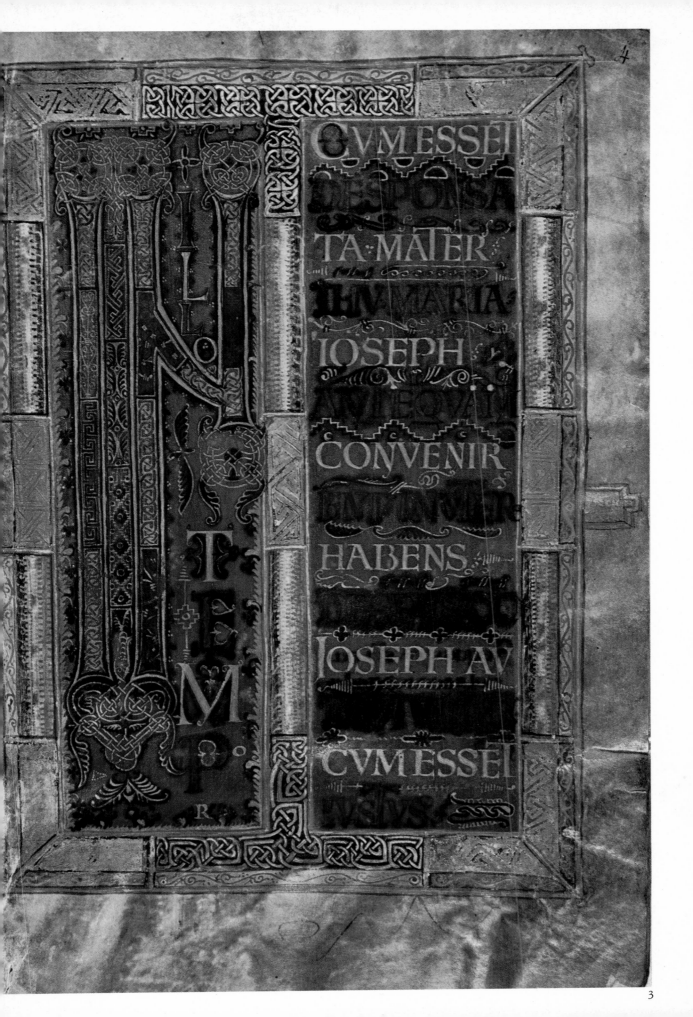

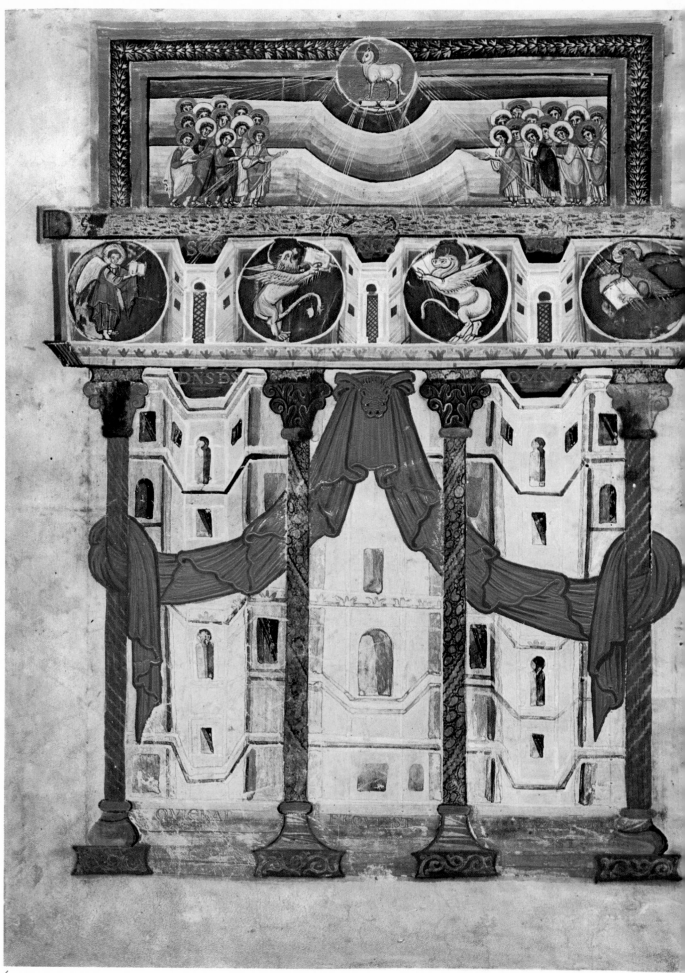

PLATE 4
GOSPELS OF SAINT MÉDARD OF SOISSONS, fol. 1v: *The Adoration of the Lamb*

Bound before the prologue of Saint Jerome, the miniature alludes to his argument on the sole authenticity of the four Gospels, based on the appearance of their symbols in chapters 4 and 5 of the Book of Revelation.

Through four columns and a curtain, suspended from a lion's head in the center, and slung around the outer columns, appears the vision of a court formed by a multi-windowed wall whose salients and recesses remain indefinite because of contradictions between perspective design and shading. The columns support a superstructure that is dominated by the Lamb of God in a gold medallion, shedding rays toward the Four-and-Twenty Elders (Revelation 4: 4–5, 10), who stand in two groups before a double-tiered expanse that curves into an apselike recession in the center. The upper molding of the architrave below contains a seascape with fish, waterfowl, and fishermen representing the "Sea of Glass" of Revelation (4:6), while the architrave itself is again filled with architecture before which are set medallions with the symbols of the four apocalyptic beasts identified with the Evangelists. Their cry "Holy, holy, holy, Lord God Almighty, which was, and is, and is to come" (Revelation 4:8) is spelled out by gold letters within the spaces left free by the upper and lower walls, and on the steps behind the bases of the columns.

A unique and original creation, this grandiose evocation of the Final Coming is yet a composite of older pictorial sources. The walls of the Heavenly City are reminiscent of the antique stage, probably transmitted through Byzantine illumination; the odd intrusion of a seascape into an architectural member is also found in the Canon Tables of the ninth century Armenian Mlkhe Gospels, although the apocalyptic theme of the Carolingian miniature points to a Western origin, just as the grouping of the Elders adoring the Lamb recalls mosaic compositions on the triumphal arches of Early Christian Roman churches.

The building of new images from parts of old ones is characteristic of Carolingian art. But the parts, while now apprehended as solid forms, are here joined in a manner unexplainable in material terms to make supernatural realities tangible.

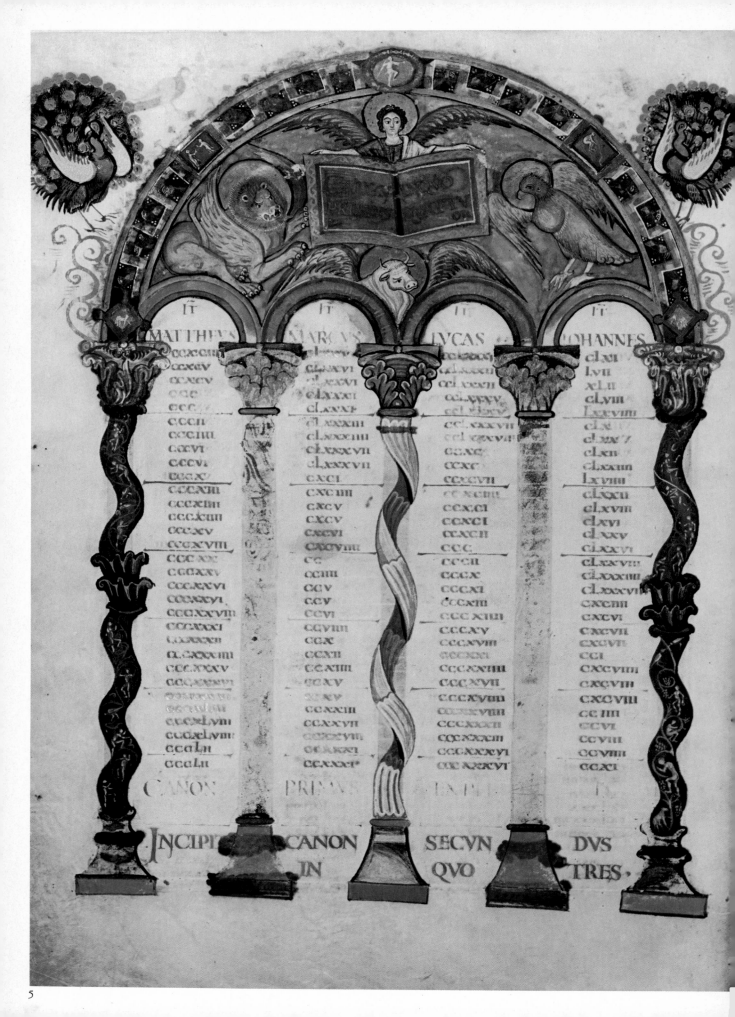

5

PLATE 5
GOSPELS OF SAINT MÉDARD OF SOISSONS, fol. 7v: *Canon Table*

The decoration of Canon Tables with architectural frames goes back to the fourth century. Their number and forms, however, as well as the flora and fauna displayed above arch or pediment, were as varied as the styles to which this convention was adapted. Canon Tables in an early Gospel Book of the Court School of Charlemagne (Paris, Bibliothèque de l'Arsenal 599) still show flat forms and motifs derived from Hiberno-Saxon illumination. But soon after, antique motifs were employed with increasing competence until, in the Soissons Gospels, there is full command of a decorative vocabulary garnered from Byzantine and Italian models.

Moreover, the debt to Rome is very evident in the spiral columns, the outer two adorned with little figures harvesting grapes. They hark back to the famous vine columns of the altar screen of Old Saint Peter's in Rome which, in the seventeenth century, inspired Bernini's great bronze tabernacle above the tomb of the Apostle. Just as these spiral columns appealed to the aesthetic sensibilities of the Baroque, so they must—beyond their reference to a venerated Christian antiquity—have appealed to the Carolingian master's taste for movement as well as for the extravagantly ornate. This taste is also manifest in the incongruous placing of simulated antique gems over the fret ornament of the arch.

The use of the space within the arch for representations of the Evangelist symbols is a medieval invention whose development can be traced through the Gospel Books of the Court School. First appearing singly above their own chapter columns, they interact in the Soissons Gospels as a group to hold, as best they can, scrolls, veils, or, as here, open books containing the number of the Canon.

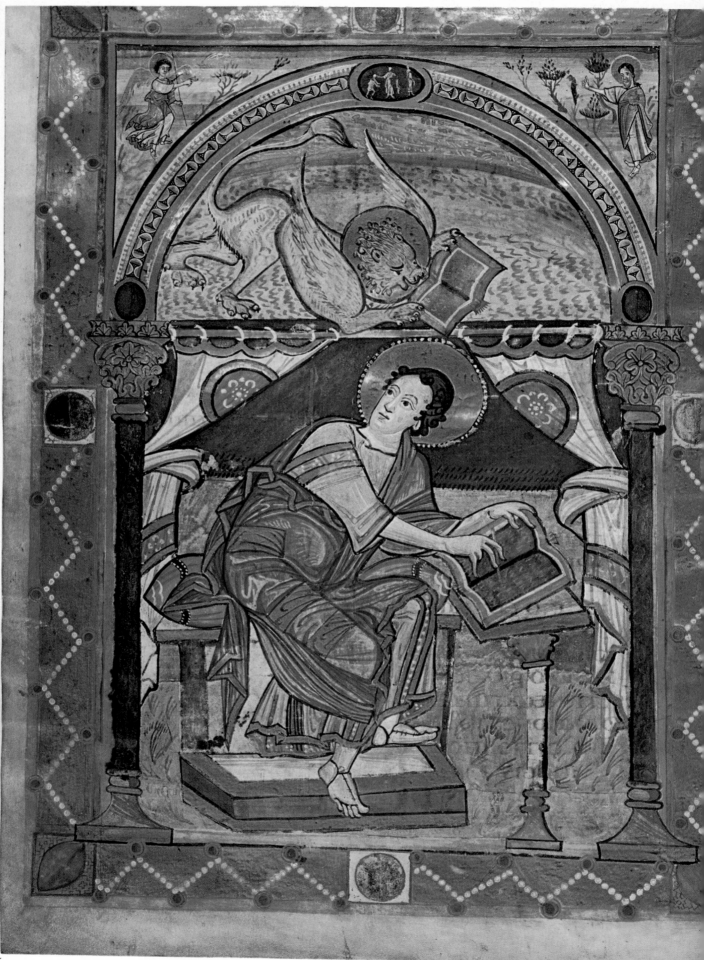

6

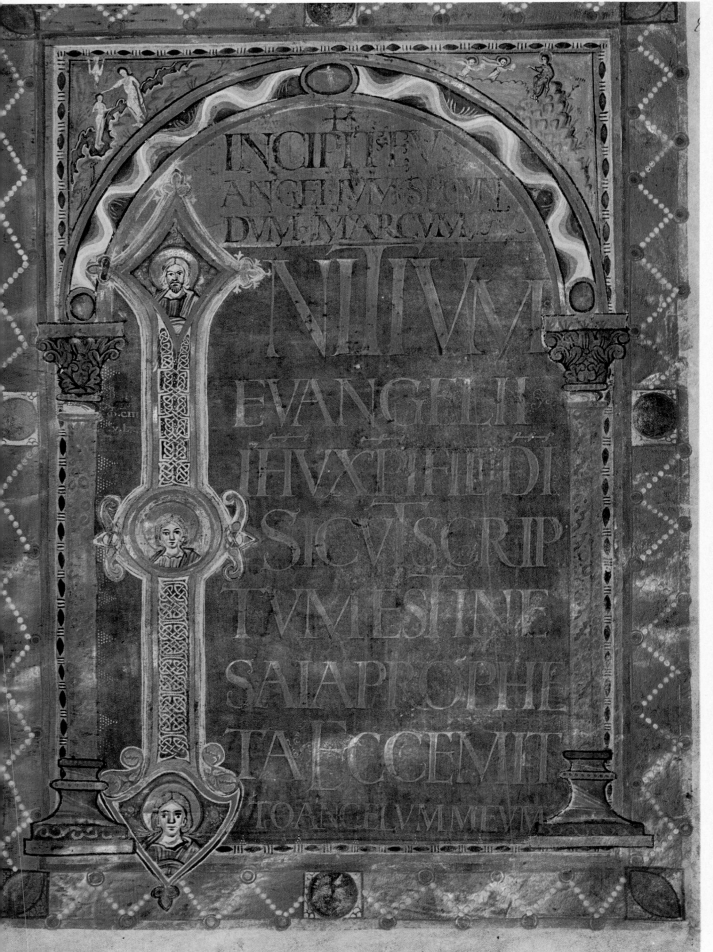

INCIPIT E
ANGELIVM SCD
DVM MARCVM

NITIVM

EVANGELII
IHV XPI FILI DI
SICVT SCRIP
TVM EST IN IE
SAIA PROPHE
TA ECCE MIT
TO ANGELVM MEVM

PLATE 6
GOSPELS OF SAINT MÉDARD OF SOISSONS, fol. 81v: *Saint Mark*

During the intervening years between the Godescalc Evangelistary and the Soissons Gospels, the illuminators of the Court School had greatly advanced in the rendering of solidly corporeal figures, particularly Evangelists. While certainly aided by newly available models from the Byzantine orbit, these masters, however, created ever newer variations of pose, setting, and furnishings by selecting and recombining single motifs absorbed from their pictorial sources.

The Saint Mark of this page, for example, repeats the posture of the Godescalc Luke but, in addition to being a young man rather than a bearded elder, he is placed between two columns surmounted by an arch, an antique device long used to enhance the dignity of important figures. A curtain rod divides the architectural setting into a space inhabited by the symbol and a lower one for the Evangelist. Such division is not conducive to the easier and more intimate colloquy between Evangelist and symbol still preserved in the Godescalc Evangelist portraits as a distant echo of the classical theme of the author inspired by his muse. Here, the lion must bend down from heaven to impart to the Evangelist the first words of the Gospel contained in the open book held in his paws. Inspiration is now bestowed by the symbol's action and received by the Evangelist's response.

Counterpoised shapes in motion create tensions which invest the composition with a vitality that, in a different key, also pervades the complex fold play of Mark's tunic and mantle. Although the garments seem to envelop a substantial body, their highlights and shades go beyond the definition of natural form and have an energetic life of their own. The potent vigor of the whole is, however, calmed by the solemn gravity of ponderous forms and ornate detail, and it is contained by the heavy golden frame decked with pearl strings and gems, as if simulating metalwork. The frame adjusts the image to the format of the page thus allowing space in the spandrels above the arch which are given to an angel on the left addressing John the Baptist on the right. The meaning of this scene in the context of an Evangelist portrait will be discussed in the commentary to the facing initial page (Plate 7).

PLATE 7

GOSPELS OF SAINT MÉDARD OF SOISSONS, fol. 82r: *Initial to the Gospel of Saint Mark*

The placing of large initial pages opposite Evangelist portraits had precedent in Insular Gospel Books, some of which also boast purple pages and metallic script in imitation of late antique luxury manuscripts. In works of the Court School of Charlemagne, however, one finds not only an increased use of ornamental motifs taken directly from Mediterranean models but also a closer correlation between the facing pages, which are joined visually as well as in meaning.

The frame of this initial page is almost identical to that of the portrait, just as the purple capital letters on gold ground for the *Incipit* and the golden ones on purple ground for the first words of the Gospel are, like the Evangelist, enclosed by an arch on two columns. Some variation is introduced by alternating the silver and gold of the columns and capitals on both pages and by different ornaments on the arches.

The large initial *I,* decorated with plaitwork of Insular type, stands out from the page and holds three nimbed bust portraits which remain unidentified. The small scenes in the spandrels, however, recall passages from the first chapter of the Gospel: verses 9–10 tell of the Baptism of Christ, shown to the left, and verse 13 mentions the Ministry of the Angels after the Temptation of Christ, depicted on the right. The figures in the spandrels of the portrait page initiate this sequence of scenes: the angel addressing John the Baptist illustrates verse 2, which is also written on the book held by the Evangelist. While these scenes might here be explained by the Gospel text, others on the portrait and initial pages to Saints Luke and John have their textual bases in the Gospel prologues rather than the Gospels themselves. It is therefore thought that these scenes were added to relate the traditional frontispiece images and initials to the commentaries of the prologues.

In any case, the presence of these little scenes, together with a small fragment from an otherwise lost manuscript representing the Announcement to Zacharias (Luke 1:11–12) (London, British Museum, Cotton Claudius B. V., fol. 132v), testify to the existence of narrative Gospel illustrations at the court of Charlemagne.

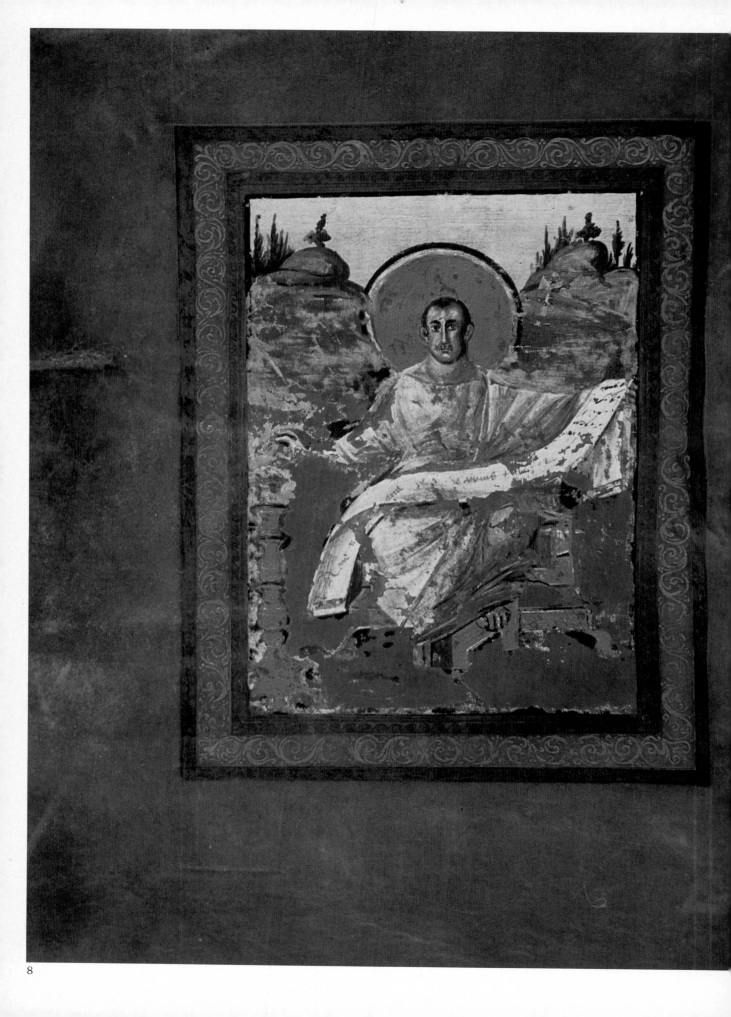

NITIVM

euangeliihuxpifiliidisic
utscriptumestinesaiapro
phetaeccemittoangelum
meumante...tuam
quipraeparabituiamtuam
uoxclamantisindesertoparateui
amdominirectasfacitesemitaseius
fuitiohannesindesertobaptizans
etpraedicansbaptismumpaeniten
tiaeinremissionempeccatoru
etegrediebaturadillomonis
iudeaeregioethierosolymitae
uniuersietbaptizabanturabillo
iniordaneflumineconfitentes
peccatasua
eteratiohannesuestituspiliscame
lietzonapelliciacircalumboseius
etlocustasetmelsiluestraede
batetpraedicabatdicensuenitfor
tiormepostmecuiusnonsumdignus
procumbenssoluerecorrigiamcal
ciamentorumeiusegobaptizauiuos

9

PLATE 8
CORONATION GOSPELS, fol. 76v: *Saint Mark* [Color losses below]

A powerful figure clad in softly falling white tunic and mantle, Saint Mark is seated in a mountainous landscape painted with broad, impressionistic brush strokes. He looks calmly at the beholder, his left hand raising a scroll that unfurls across his knee, while he refreshes the pen in his right hand from an inkwell on a stand to the left. Were it not for the large halo, one would imagine this figure to be an antique author, serene, wholly self-contained, and without need for inspiration from a symbol.

The contrast to Evangelist portraits of the Court School proper is striking, indeed. Whereas the latter were composed from many heterogeneous sources into images of ornate but remote magnificence, antique humanism seems recovered here all at once. The figure is modeled by means of lighter and darker tones of basic colors, as in antique painting. It is of a firmness and monument-ality, however, which has suggested that its painter might have been a muralist. If so, he adapted himself well to book illumination. The astute *mise-en-page* of the picture, allowing for broad margins, recalls the same practice in late antique codices, while the border, which is part of an ornamental whole in the Court School manuscripts, performs here once more the function of a picture frame, besides being decorated with foliate and "Vitruvian" scrolls of almost classical purity.

The creation of such work under the same patronage as the productions of the Court School testifies to the scope of the revival ambitions and successes of Charlemagne and his advisers, among them Einhard, his biographer to-be, who headed the Court scriptorium at the time this manuscript was composed. It was he, in all probability, who summoned to the court the painters of the Coro-nation Gospels who firmly implanted the retrospective ideal of late classical art in the North.

PLATE 9
CORONATION GOSPELS, fol. 77r: *Beginning of Saint Mark's Gospel*

Bibliophiles will savor the restrained elegance of this page. Although it faces the portrait of Saint Mark, no effort has been made to unite both pages by shared ornamental devices or thematic reciprocity as was the habit in the Gospel Books of the Court School of Charlemagne. Instead, the autonomy of image and of text is underlined by the use of differently tinted parchment. The only correlation is a typographical one, namely the confinement of the lines of text to a field commensurate to the framed portrait on the left, leaving the same marginal proportions. Otherwise, each page stands apart and on its own, due to the proper concerns of painter and scribe who pursued, each in his own medium, their common aim to create a book which was to imitate and improve upon late antique tradition. The form of the uncial script resembles sixth century Italian work far more than it does the contemporary uncials of the Court School scribes who, moreover, did not employ the old form of rustic capitals for the *Incipits* of the Gospels, such as found here.

The initial, however, is a concession to Carolingian taste. While its interlace echoes Insular conceits, it has been shown to be a variation on examples which the scribe is sure to have found in early manuscripts of the Court School. But he tempered their forms in harmony with the measured rhythm of his letters to maintain the classical austerity of the page design.

This knowledge of early Court School work, also noted in close parallels between text variants and the selection and order of prefatory materials, confirms the proximity of the Coronation Gospels to the court of Charlemagne, as well as its date of before 800. But when seen against the richly framed decorated pages of the Court School proper, this work stands as a strong object lesson in the recovery of antique form.

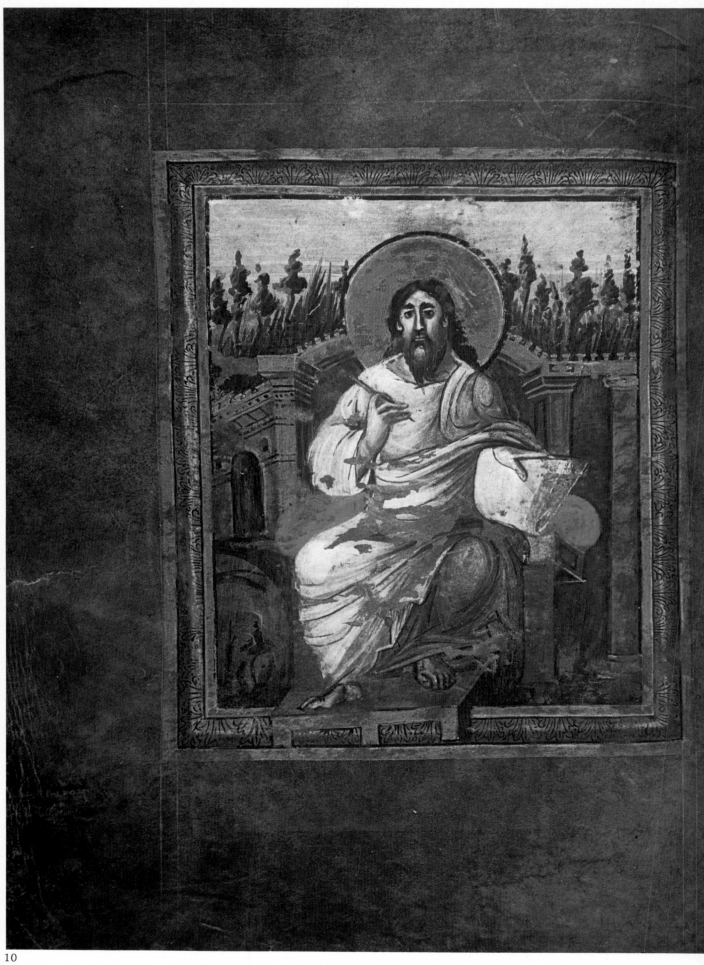

10

PLATE 10
CORONATION GOSPELS, fol. 178v: *Saint John*

The illusionistic technique, which the painter of the Saint Mark portrait had mastered with such authority, is modified by thin black lines on this image of Saint John, which is by another hand. This master also ignored the original sense of the frame by projecting the Evangelist's footstool out of the picture in a manner more medieval than antique.

Nevertheless, he was schooled in the same Hellenistic tradition of late antique painting as his colleague, and both must have been foreigners, called to Charlemagne's court from south of the Alps. Their actual origin, however, remains one of the most tantalizing questions posed by early medieval art. No surviving Italian work of the later eighth century affords valid comparisons, while the nature of the stylistic currents of art in the Greek East, then embroiled in the Iconoclastic Controversy and wholesale destruction of holy images, is still largely a matter of conjecture.

These facts notwithstanding, the two painters of the Coronation Gospels were surely trained in an atelier concerned with the perpetuation of the ideals of late classical art, and some indications seem to favor a Byzantine environment. The absence of the Evangelists' symbols is a characteristic early Byzantine feature, and the architectural settings, providing—as on this page—a spatial niche for seated Evangelists, are found, for instance, in a Gospel Book from Constantinople (Mount Athos, Stauronitika, Cod. 43) which, while being dated into the tenth century, betrays a much earlier model by its style. The entry in Latin of the Greek name *Demetrius Presbyter* on the margin of the first page of Saint Luke's Gospel may also be significant. In any event, the painters are most likely to have been Greeks. Whether they arrived at Charles's court directly from the East or after a protracted sojourn in Italy, we shall probably never know.

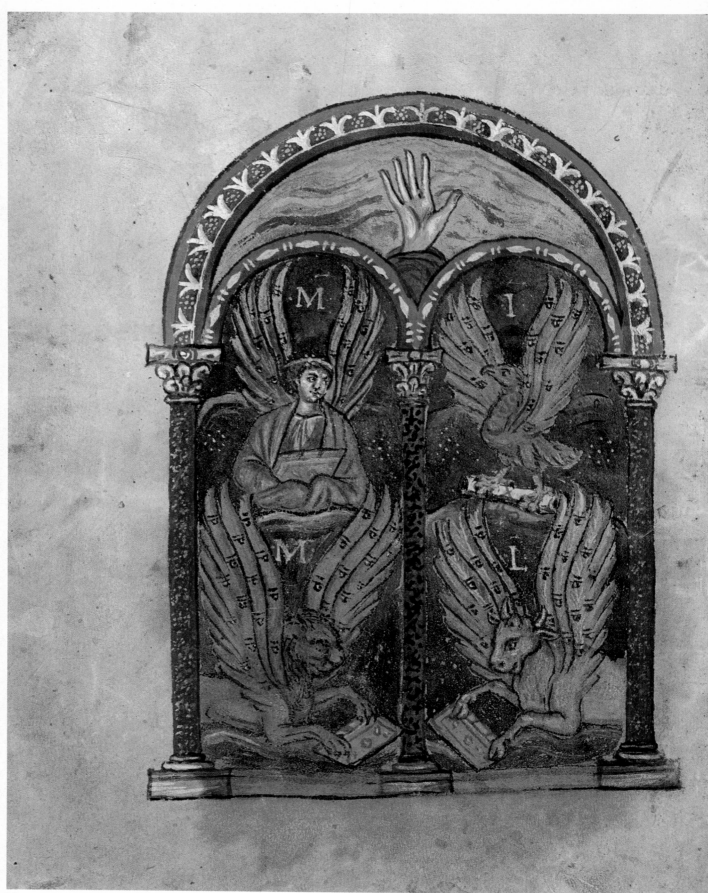

PLATE 11
GOSPELS, fol. 8v: *The Hand of God and the Symbols of the Four Evangelists*

Instead of individual Evangelist portraits, this manuscript contains only one miniature for all four Gospels. Enclosed within an architectural frame that repeats the arcade forms of the preceding Canon Tables, the symbols of the Evangelists emerge from cloud banks on a starred blue sky, while the hand of God appears before blue and rose cloud strips below the encompassing arch.

Although less versed in the technique of illusionistic painting than the masters of the Coronation Gospels (Plates 8,10), the painter still achieved an effect of rounded surfaces by coloristic means, particularly in the figure of the "man" of Matthew. He must have worked from a very good model—a model, moreover, in which the apocalyptic significance of the symbols was emphasized, rather than their connection with the Evangelists. Unlike any other known Carolingian rendering of Evangelist symbols, their wings have eyes and are tripartite, exactly as described in the Book of Revelation (4:6,8). Such beasts with tripartite wings and without halo are, however, found on fifth century Italian mosaics, thus indicating the age and provenance of the model. The hand of God appears also frequently in Early Christian art as a sign of his Word, as well as his creative and protective power, a meaning still potent on this page.

Yet it is not the presence of a model which accounts for the departure from the usual pictorial program of Carolingian Gospel Books, but the manuscript's origin at Fleury. The monastery belonged to the diocese of Bishop Theodulf of Orleans, who has been recognized as the author of the *Libri Carolini*, a treatise arguing on several points against the decision of the Council of Nicea (787), which had reinstituted holy images in Byzantium. This attitude is reflected in all religious works of art which can be attributed to Theodulf's patronage. His Bibles, though illuminated with splendid Canon Tables in a late antique style, have no miniatures, and the mosaic decoration of his chapel at Germigny-des-Prés consists only of Old Testament symbols, particularly the Ark of the Covenant. Whether or not this Gospel Book was made for Theodulf himself, its lack of Evangelist portraits or an image of Christ is surely connected with the Bishop's aversion to their portrayal.

REXREGVMDOMINVSMVNDVMDICIONEGVBERNANS
IMPERIA SCEPTRVMREGNANSQ IVREPERENNI
INMORTAL TENESCVMCRIMINAMVLTAPARENTVM
LAXAST CELVSTITIAECVMFRENALOCARAS
OMNIBVSE GOTVISSERVISSVPERASTRABEATA
SPERAREH INCVITA CITOCHRISTEDEDISTI
DQNIQVEE TMO DO EDEVSPATRISQETVIQE
NVNCNOME NI DRIT IAMC VNCTASTVPEBANT
SAECVLADVD VMEN ERT CEQO AGESTATVRAMICA
SVMMIXPICO LEDV NATR ITEGERENDVMHOC
PERIVSTAM QTH RE VMAV IDOQODTOLLERELEGEM
ATQDECET TOTMAV GVSTVSNVTVEXCOLATORBE
NAMHOC FAC NVSTAM TOCIRANDOCARDINEPRODIT
ORBSS CII VTCAEAMO SVLTVCAESARISORET
AVGVSTOB RE EBEIAL HINCLAVDECORONAM
NAMOPTIM ES DEXTRAMV DIVINAPARETARTE
STIPSIES TYADETOTRI VMPOSCIMVSOMNES
IAMALMVM VSTOIVSTITI QVODREGNETVBIQE
HAECSILI EVNOVATATQ IGATVGIRETAMICO
DVMADFER LO VICAPLAC SICIPSAPARATVM
OPTEMVSN SSEMPERQ VEMPIECHRISTVS
RETVTATV QVAQ LLVSIA LOPREMITASTFVR
FASVELIN VLO TRECNHO TISCRIMINEDIRO
DEFENSOR RTISSER RIC ONSTRATAMANDVM
IVSORNAT LAEATCAESARI BTINETHAVSTVM
OMENFITQ AMGETVTVMIMPERI VMMANETORBE
ENREGNAG ALAMOMINEPERXEREV MVNERADONANT
ETPERSAD ATLSICVIVSCOLASISI TVSAMBIT
GENSPLEB TLETAPROPAGOS IN AMPIEDONAT
MVSAMVLV TEDENSMANEATSCVTV ETAMARE
SPEMEXSV SCEPTRATENENDO FIDEIDATVBIQ
REMHAVST DOMOSAECLAV DEPELLITABARTE
QAEFORMO ERVRATENEBVT TTELANEFASSINT
ETSEDARE IE TERRAESON IDANDAFROTERVIAM
QVAMESTS LIIVSPERBANC TEGITAVGVSTOVILE
TRANSFOR ATORBISSCRITI CVMCLARATRIBVTA
IVRECOLE DI MMEMORE QTROPAEPARANSDAT
QVAEHOCS NOMENTALI MEANSORVMABORE
NEMPETON TVRGETQVEPRO BPECTVSDIVAMARI
SITTREMO ESTGVEBONAE DVINOMVNEREFAMAE
PROFICIT NDEOGEMA DVMPRETVMINLICITAQ
SICABICI PORTVCRVCE DATLAESVMSEQITVRQ
HVNCTIBI NIMINDODATVMOSEMPERCASTQPTVQ
CAESARLA GEMODOVISVTVCASTRAINIMICIAST
TERRESSP MQETIMORALDVINIMICAFVGANSDAT
TVPIVSET RATNIVMIVMPHONVMROGATHAECGENS
ADVENIAM REANIVVSNOBISADIVSSAPARENTIS
CONSCRIP IDVDVMNAMCRISTILAVDELIBELLVM
VERSIBVSETPROSATIBIQEMNVNCINDVPERATOR
OFFEROSANCTELIBENSCVIVSPRAECEDITIMAGO
STANSARMATAFIDEVICTOREMMONSTRATVBIQVE

PLATE 12
HRABANUS MAURUS, DE LAUDIBUS S. CRUCIS, fol. 4v: *Louis the Pious*

Hardly outstanding for its artistic merit, this page is significant for two reasons. It is the first instance of a contemporary text adorned with miniatures, and it is the first preserved portrait of a Carolingian Emperor in manuscript illumination. This claim to originality, however, does not extend to the form of either the text or the image.

The enclosure of sets of letters by the contours of patterns or figures to form independently consistent phrases or verses in an otherwise continuous text was a fancy of late antique literati, foremost among them Optatianus Porphyrius, court poet of Constantine the Great. These *carmina figurata* appealed to early medieval scholars and scribes and were copied, as well as imitated, throughout the early Middle Ages long before Hrabanus wrote his work. From the wordy encomium on this page, for instance, the letters within the halo of Louis are isolated to spell "You Christ crown Louis," while those in the cross-staff read "The true victory and salvation of the King are all rightly in your cross, Christ."

In keeping with the dedication praising Louis as the militant defender of Christ, he is represented as a Christian warrior. His military dress is that of a late antique general, while his frontal pose, the halo, and the way in which he holds the cross-staff and shield closely resemble late Roman representations of emperors. Hrabanus, as well as the painter, must have had such an imperial image at their disposal when they devised and painted the portrait of their sovereign, which is certainly not a likeness in the modern sense.

Thus, the form of Hrabanus's tract and the artist's work are indebted to sources of ultimately the same late antique origin, although we do not know whether the models for both reached the scriptorium of Fulda by the same or by different roads.

PLATE 13
EBO GOSPELS, fol. 13r: *Canon Table*

The course of Carolingian art was changed profoundly when the late classical forms and illusionistic technique introduced by the painters of the Coronation Gospels were carried into other scriptoria. Ebo, a commoner educated at the court as the foster brother of Louis the Pious, and later serving him in Aquitaine, certainly knew the work of these foreigners. When he became Archbishop of Reims in 816, their example was to provide the point of departure for the native illuminators assembled under his patronage at Hautvillers.

The painter of the Ebo Gospels, however, neither copied the Canon Tables of the Coronation Gospels nor any of the few later known works advancing a similar style. Although his architectural frames resemble antique temple fronts, as they do in these manuscripts, the gabled pediments are supported by only two columns instead of the several which usually divide the rows of chapter numerals. The resulting effect of lightness and elegance is further enhanced by classical motifs in the moldings, here a pattern of "wind-swept" acanthus leaves. Some of the columns are treated with a particular whimsy by giving them narrow openings that hold palm branches.

Most astounding is the vivacious life portrayed on the gables. Here, a hunter has thrown a spear into a lion, who recoils with surprise. On other folios, there are hunters aiming at or chasing birds; there are trees, plants, birds, lions, grazing sheep, men working on the pediment with ax or chisel and hammer, men reading or hunched over in thought, and more. The decoration of Canon arches with plants, animals, and, sometimes, figures is an old tradition, but no convincing explanation has been found for the meaning of these extraordinary drôleries. Their vibrant style, however, is found again in the Utrecht Psalter (Figures I, II), suggesting that the artist also had had a hand in this chef-d'oeuvre of Carolingian art.

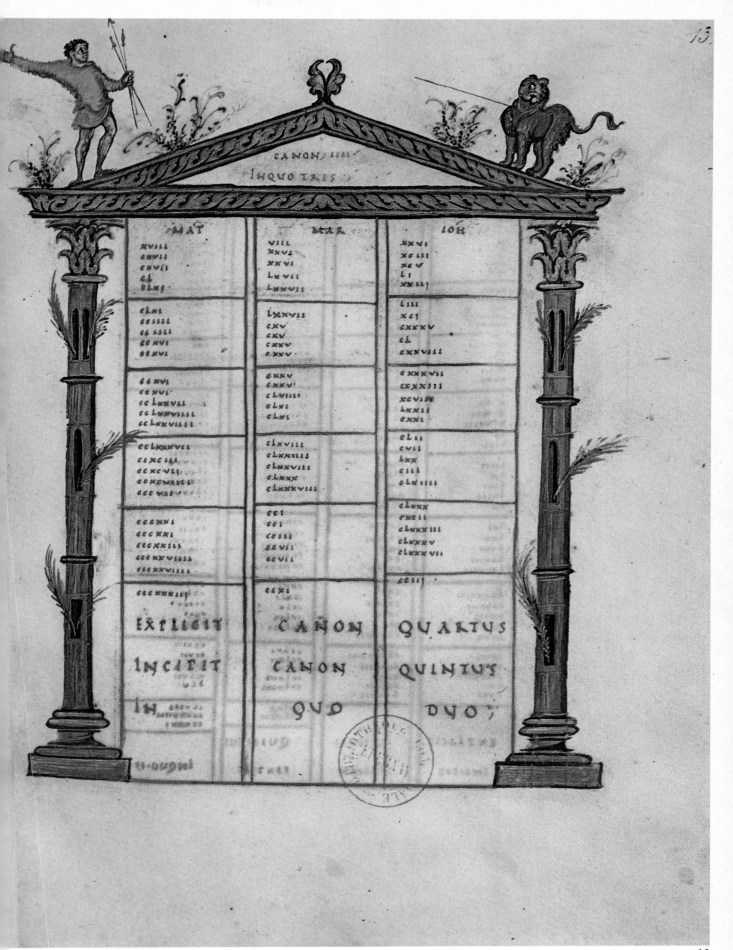

PLATE 14
EBO GOSPELS, fol. 18v: *Saint Matthew*

No calm and dignified author like the Evangelist of the Coronation Gospels, this Saint Matthew appears as a man possessed. But it is not only his hunched pose of intense concentration, eyes and pen keen on the task, which convey this sense, nor the wild curls of his hair, it is the way in which the whole image is painted.

Having absorbed the lessons of antique painting taught by the masters of the Coronation Gospels and their followers, the Ebo painter now turned these lessons into a new and wholly original language expressing a psychic power unknown to late antique art. He wielded his brush with a vehement, nervous energy that transcends the original purpose of modeling with light and shade for the rendering of firm bodies in atmospheric space. The turbulent massing of gray shades and scintillating golden highlights agitate Saint Matthew's white robe more than model it. The Evangelist seems seized by an unaccountable force, a force here neither sanctified by a halo around his head nor ostensibly inspired by his symbol, the winged man, who is sketchily drawn as a small figure in the upper right-hand corner, as though on an afterthought. But the landscape echoes the exaltation of the Evangelist. While the soft colors and the small buildings on the high horizon recall illusionistic, antique landscape painting, the slashing brush, used almost like a pen, created hills, billowing and heaving as if also shaken by a divine tremor.

More than the solitary vision of a great artist, this work represents an entirely new departure that was to influence northern medieval art for centuries to come. The Ebo painter reconciled the disparate aims pursued a generation earlier by the artists working at the court of Charlemagne: the masters of the Court School whose ornate and remote images inspire awe rather than empathy, and the foreigners of the Coronation Gospels who brought the humanistic ideal of classical art to the North. The new element in this fusion was the conversion of religious awe into a religious fervor which now stirs the Evangelists from the tranquility they possessed in the Coronation Gospels into a state of exaltation.

PLATE 15
Eʙᴏ Gᴏsᴘᴇʟs, fol. 19r: *Initial page to the Gospel of Saint Matthew*

The contrast between the portrait of Saint Matthew and this facing page, containing the *Incipit* and the first verse of his Gospel, is very impressive. The words which the painter had the Evangelist write down with such tempestuous fervor shine here in lucid clarity.

The calligrapher must also have known a manuscript of the style of the Coronation Gospels. As there, the page is unframed and stands on its own (Plate 9). But, like the painter, he converted the classical impulse to new aims. This is no longer a text page with an initial, but an initial page proper, the following leaves being written in minuscule. Moreover, the initial has regained the preeminence it held in manuscripts of the Court School of Charlemagne. The artist was surely indebted to forms and motifs developed and used by this school and he must have exercised his hand on such and, perhaps, other models for years, as is evidenced by the taut discipline and originality of his design.

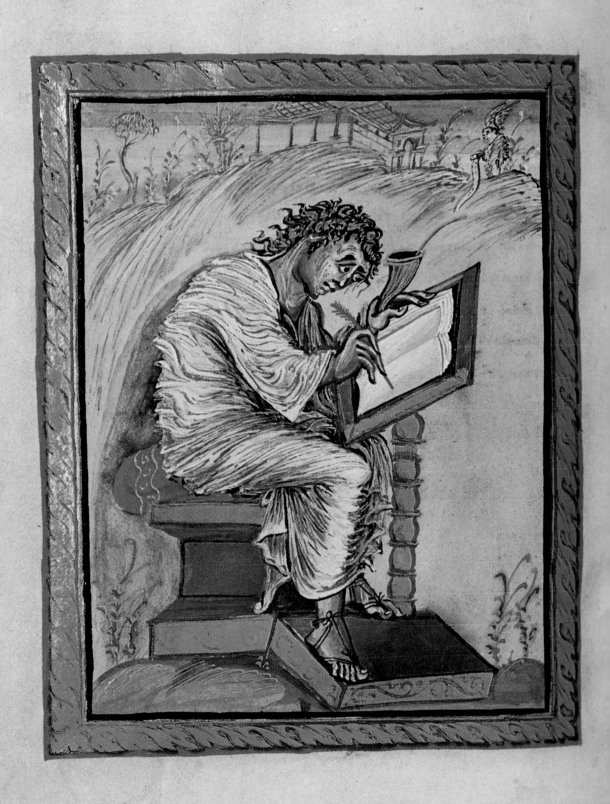

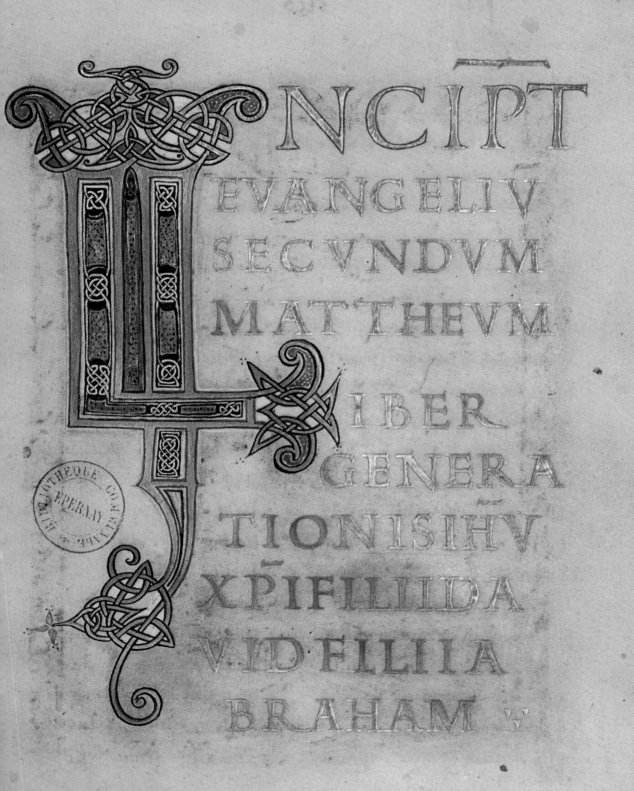

NCĪPT
EVANGELIŪ
SECVNDVM
MATTHEVM
IBER
GENERA
TIONISIHŪ
XPĪFILIIDA
VIDFILIIA
BRAHAM

PLATE 15 (*Continued*)

Near geometric precision stabilizes the metallic structure of the intersecting letters *L* and *I* which—a new conceit—serve the *I(ncipit)* as well as the word *L(iber),* beginning the text. The interlace continuing the golden frames of the stems into crown and tails is equally precise, appearing almost as if laid down with compass and ruler but terminating in curls suggestive of the vegetal flexibility of tendrils, which may even sprout a trilobed leaf as at the point of the tail of the letter *I*. Finally, the coloring of the interstices of the interlace as well as the black ground within the stems of the letters, filled with plaitwork alternating with and binding stippled fields, lends the initial its due prominence over the austere golden capital letters.

PLATE 16

PHYSIOLOGUS, fol. 12v:
On the fourth Nature of the Serpent; On the first and second Nature of Ants

Three sections of the *Physiologus* are illustrated here. In the upper left:
When a man kills the serpent, it exposes its body but protects its head. Thus,
in times of temptation, we must yield the body but hold up the head, so as not to
deny Christ but follow the martyrs. In the space between the upper and middle
text column: When the ant garners wheat it splits the kernel into two parts
so that it cannot sprout and spoil its nourishment. Thus, one must distinguish
letter and spirit in the Old Testament so as not to be starved to death like the
Jews, who comprehend only the bodily aspect. To the left of the last text
column: At harvest, the ant separates wheat from barley by its odor and leaves
the latter for cattle. The barley stands for false doctrine, the wheat for true
faith.

DEQUARTA NATR SERPETS

Quando uenerit homo & uoluerit
occidere eum totum corpus tradit
caput aut custodit· Debemus & nos
intempore temptationis totum cor
pus tradere· caput aut custodire· ide
xpm nonneganter sicut fecerunt
sci martyres· omnis enim caput xps est

DE NAR FORMICAE

Quando recondit triticum interra diuidit & grana eius
induas partes neforte hiems conphendit eam & infundens
pluuia & germinent grana & fame pereant· Et uuerba
ueteris testamenti adspiritalem intellectum nequan
do littera occidit· Paulus dix qm lex spiritalis est· Solum
enim carnaliter adtendentes iudei fame negatisunt
& homicide factisunt prophetarum

DE NATR FORMICES SECTIO

Sepius inagro uadit ascendit inspi
ca intempore messis & deponit gra
na euis priusquam ascendit adorat
deorsum spicam & ab odore magna

PLATE 16 *(Continued)*

Compounding ancient natural science, folklore, and Christian moral allegory, the *Physiologus* was brought into the Middle Ages by the Carolingian interest in antique knowledge, and became the precursor of medieval Bestiaries. The miniatures of the Bern codex, whether unframed as here, or framed pictures with landscape settings as in the majority of pages, were certainly copied from an illustrated *Physiologus* manuscript. The first illustrated Latin edition is believed to have been composed in the late fourth or the fifth century, but it is uncertain whether the work available at Reims was of such an early date or a later copy which transmitted the late antique style of painting to the Bern miniatures.

In any event, this model must have contributed to the formation of the "illusionistic" style flourishing at Reims during the tenure of Archbishop Ebo. There are strong stylistic affinities and even shared motifs between the Bern *Physiologus* and the Utrecht Psalter, although the hand of the *Physiologus* artist was not possessed of the vibrant energy distinguishing the pen drawings of the Psalter or the paintings of the Ebo Gospels.

PLATE 17
PSALTER OF KING LOUIS, fol. 3r: *Beginning to Psalm I*

The design and decoration of initials or initial pages reveals the fundamental aesthetic sensibilities of the various Carolingian centers of manuscript illumination more clearly than does miniature painting. Although Hiberno-Saxon influence, already received and translated at the Court School of Charlemagne (see Plate 3), had left a lasting imprint on Carolingian initials in general, there exists a large group of manuscripts without miniatures—usually called Franco-Saxon and produced over half a century, mostly in northern France—in which Insular motifs outlasted and prevailed over the decorative vocabulary of Mediterranean origin employed more eagerly by other schools.

The Psalter of King Louis represents an early branch (St. Omer) of Franco-Saxon illumination, but its luminous pages already show a characteristic bent for the restrained and delicate use of gold and carefully attuned colors enhancing the natural tone of the parchment page, and, above all, a striving for harmonious proportion, as well as a subtle balance between dynamic and static form (see Plate 48). Here, the frame does not impose such a balance, but rather partakes of it. Frame, initial, letters and decorative detail of this *Beatus Vir* page seem held in equilibrium as if by an underlying grid, which yet allows each element and detail to play its own role. The sinuously curving large initial *B* with its interlace pendents and birds' heads tail, the Insular bird and dragon heads which emerge from a multicolored checker pattern at the corners of the frame only to bite back into it, as well as the ornaments which break through the frame at the center of its top and bottom, or swell it on the sides, all lure the eye individually, while still acting in concert.

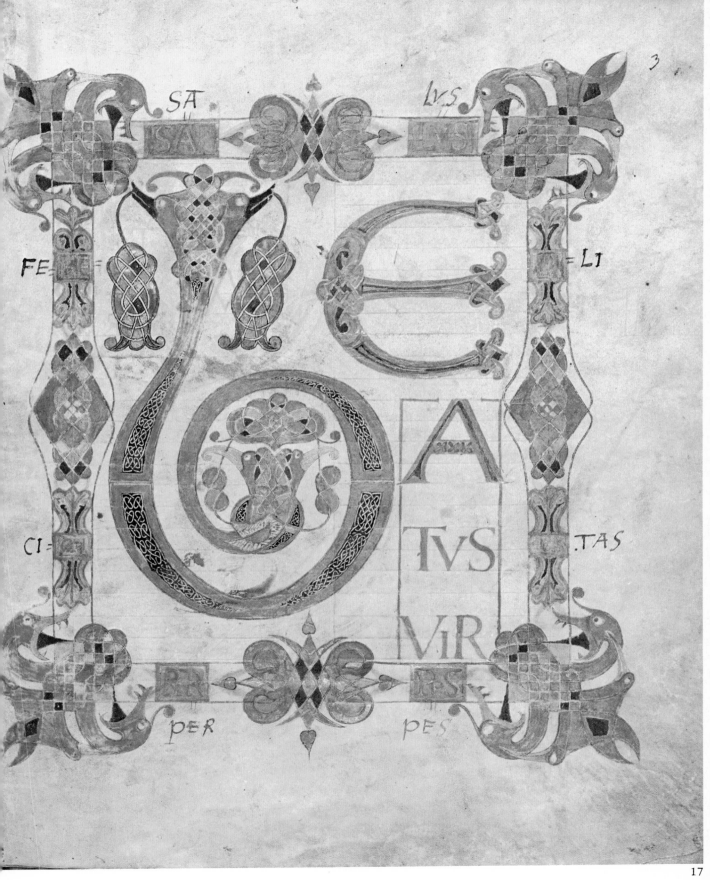

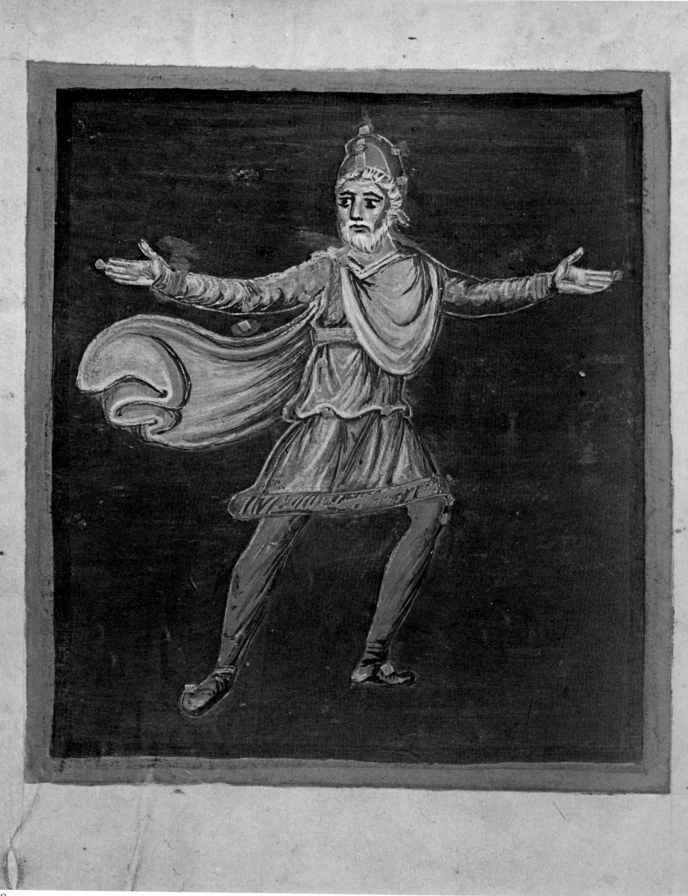

PLATE 18
ARATEA, fol. 26v: *Cepheus*

As explained on the accompanying leaves by the text of Germanicus (V, 184–192), this miniature represents Cepheus, the unhappy Ethiopian king of Greek myth whom the Gods had raised among the stars after his death, as they had his wife, Cassiopeia, and his daughter, Andromeda. He is clad in Phrygian garb and the stars of his constellation are indicated by small golden dots. The blue ground is enclosed by a simple red frame, characteristic of late antique manuscript illustration.

Indeed, the miniature might be included in a book on antique, as well as Carolingian, painting. A probably mid-fourth century work has been reproduced here with such extraordinary faith to subject matter and format, as well as technique and style of painting, that it is difficult to discover specifically Carolingian features. Even the slight awkwardness of the posture, although less evident than in some other pages of the manuscript, may already have been present in the copyist's model.

It is for this reason, and because of the absence of identifiable idiosyncrasies of script, that the manuscript cannot be connected with any of the known major Carolingian scriptoria which had developed their own distinct styles of painting, particularly in manuscripts with religious content. The urge to create new forms of pictorial expression seems to have been deliberately suspended vis-à-vis secular manuscripts, seen also in two somewhat earlier related works, an illustrated Terence (Rome, Biblioteca Vaticana, Vat. lat. 3868) and an Aratea in the translation of Cicero (London, British Museum, Harley Ms. 647).

Still, the topic of the work and the care lavished on its miniatures point, as has been convincingly argued, to a demanding patron of high rank with an interest in humanistic learning at the court of Louis the Pious, perhaps his oldest son, Lothair I.

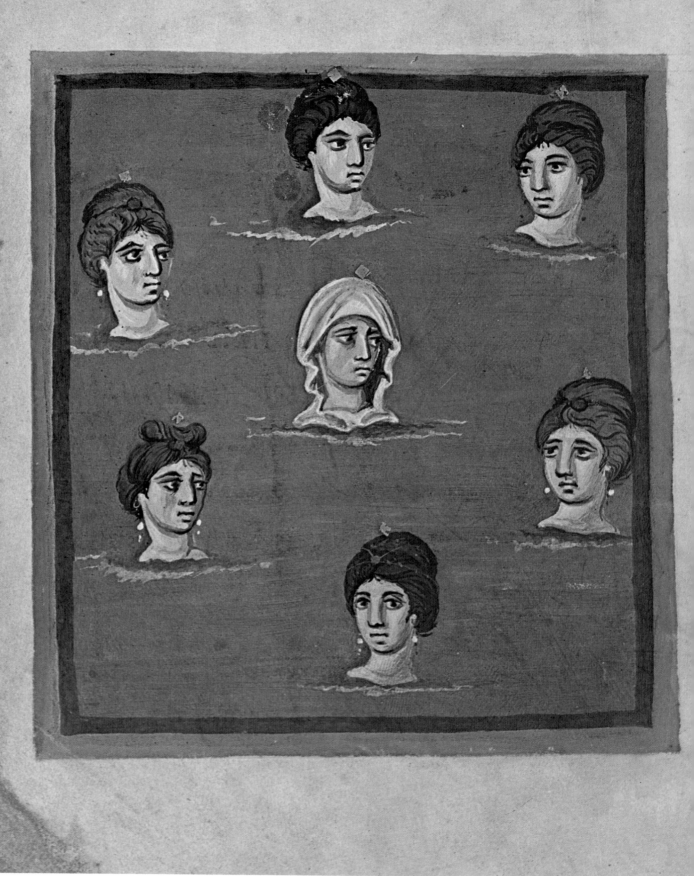

19

PLATE 19
ARATEA, fol. 42v: *Pleiades*

The lovely heads emerging from cloud banks in the blue sky represent the Pleiades, the seven daughters of Atlas and the nymph Pleione, who were transformed into a group of stars. While six wear elegant, late antique hair styles, the seventh in the center is covered by a veil. She must be the lost star, Merope, who, according to myth, concealed herself out of shame for having loved a mortal, Sisyphus of Corinth.

This particular myth is not elaborated upon in the poem of Aratos, nor in the Latin version of Germanicus Caesar which is translated into English here:*

"Under Perseus' left knee, Taurus' most sure signs
The Pleiades will be nigh. A small space contains them all.
They are hard to see, save that their several stars converging
Shine forth one common flame from all.
Seven they number, tradition says, yet one is plucked away,
When failing eye fails to separate their tiny bodies.
But antiquity, trustworthy, has preserved the names of all:
Electra and Halycon, Celaeno and Merope,
And Asterope and Taygete and Maia,
Born of a Father who shoulders the sky, if truly
Atlas bears Jove's realms and the celestial ones, and in the very weight delights.
In light the Pleiades will not have vied with many stars,
But they with signal honor harbinger two times of year,
When first the ripening season comes upon the farmer
And when winter rises, which those who know, know they must flee with harbor's refuge."

*[translation by William E. Higgins]

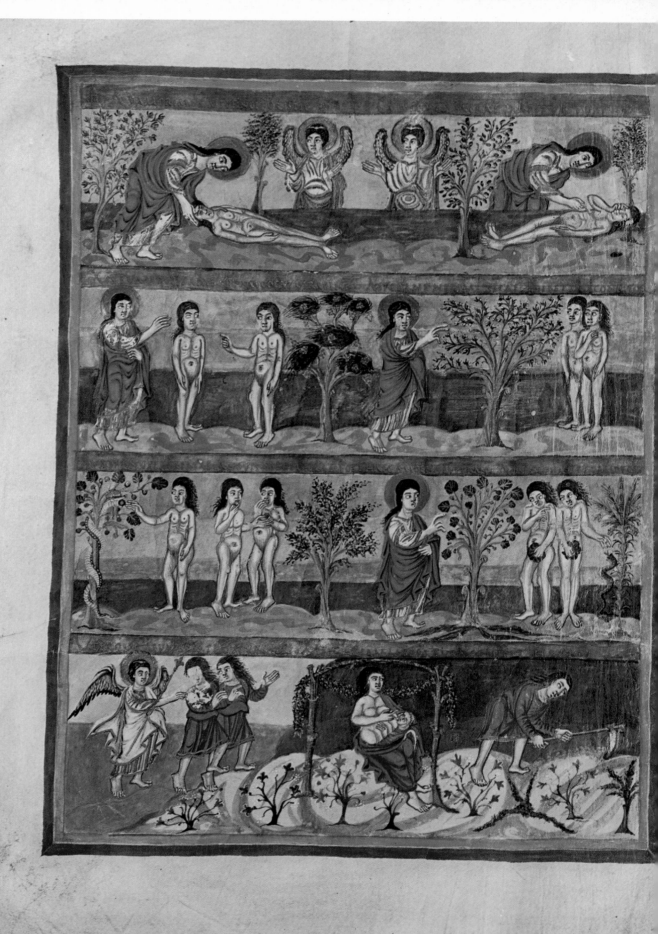

PLATE 20
GRANDVAL BIBLE, fol. 5v: *Frontispiece to Genesis*

Single Books of the Bible or groups of Books such as the Pentateuch (the first five Books of the Old Testament) had already been copiously illustrated in Early Christian times, whereas the illustration of entire Bible manuscripts with frontispiece miniatures was only slowly developed by excerpting and adapting Early Christian picture cycles, or their Greek and Latin descendents, to the format of one volume Bible editions. This development received a strong impetus in the Carolingian scriptorium of Tours which Alcuin, Abbot from 796 to 804, had made into a leading center of Bible reform and production. Alcuin, however, was mainly concerned with the establishment of a pure text, and it was only under his second successor, Abbot Adalhard (838–843), that Bibles received a limited number of full-page miniatures which, more than just illustrations of Bible stories, were to convey the history of man's fall and redemption.

This page depicts the Creation and Fall of Man in four horizontal panels which are accompanied by purple bands with verses identifying the scenes, all illustrating episodes related in the Book of Genesis: the Shaping of Adam (2:7) and the taking of the rib for the Creation of Eve (2:21); Eve Presented to Adam (2:22–25) and the Lord's Prohibition (2:16–17, 3:3); the Temptation and Fall (3:1–6) and the Lord's Reproval (3:17–19); the Expulsion (3:23–24) and the Labor of the Parents, with Eve sitting under a bower suckling Cain, and Adam tilling the earth (3:17–23).

The events of the first three panels take place on a continuous earth ground before blue and rose colored bands that are conventionalized adaptations of the atmospheric sky of late antique painting. The figure of the Lord, always turned toward the right, provides at once punctuation and continuity, just as do the inserted trees. The change of the landscape in the last panel conveys the loss of Eden: The couple are driven as through a void onto the rising ground on which grow "thorns and thistles" (3:18) among which Adam and Eve must labor. Although the gestures of the figures are stereotyped, their meaning is entirely clear as, for example, in the scene of the Reproval, where Adam passes the Lord's accusation along to Eve who, in turn, points to the serpent (3:12–14).

PLATE 20 *(Continued)*

The representation of the Lord Creator as Christ, the preexistent "Word" according to the Gospel of John (1:1), follows a doctrine already promulgated by the Church Fathers, and all scenes, including the two angels in the first panel, are ultimately derived from a much larger cycle of separate miniatures, known as the Cotton Genesis recension after the earliest preserved—although now sadly fragmentary—illustrated Book of Genesis from the fifth or sixth century (London, British Museum, Cotton Otho B. VI).

The long-held conviction that the content and format of the Genesis, as well as the other three frontispiece minatures of the Grandval Bible, were copied from a mid-fifth century Bible commissioned in Rome by Pope Leo the Great, which had found its way to Tours, has recently been challenged by the conjecture that the Carolingian masters themselves had excerpted and rearranged to full-page size single scenes from extensively illustrated separate biblical Books of Genesis, Exodus, and the Apocalypse. The last word on this important question on the Carolingian or earlier origin of Bibles with frontispiece miniatures is still to be heard. But whatever the answer, it was at Tours that the number of full-page Bible images was increased, as witnessed by the somewhat later Vivian Bible (see Plates 21–24), and it was from Tours that the painters of the Bible of San Paolo received models for many of their frontispieces (see Plate 45).

PLATE 21
VIVIAN BIBLE, fol. 3v: *Frontispiece to the Prefaces of Saint Jerome*

Scenes from the life of Saint Jerome are arranged in three horizontal panels
with verses on purple bands below each one, explaining the episodes which are
culled from the Saint's own writings. Above and to the left, Saint Jerome leaves
a city that is identified as Rome by the personification of *Roma* holding a lance
and shield as she does in numerous antique representations. A ship is about to
sail for the Holy Land, where, to the right, we see the Saint paying his teacher
of Hebrew. The second panel shows Saint Jerome instructing Saint Paula, her
daughter Eustochium, and other ladies who had followed him from Rome, in
the Holy Scriptures, which are transcribed by the clerics to the right. In the
botttom panel, he distributes the completed Vulgate Bibles which are being
stored in buildings to his right and left.

21

PLATE 21 *(Continued)*

Although the artist clothed Saint Jerome and his clerics in Carolingian rather than Early Christian garb, his familiarity with late antique painting is evident in his rendering of the buildings, the ship and the pseudoatmospheric sky, as well as by the corporeality of the figures. Still, the miniature cannot be shown to be a copy of an earlier work on the same subject since no late antique narrative scenes of Saint Jerome's life are known. Motifs and devices which the master borrowed from other contexts seem to have been adapted here to a new theme. Moreover, he translated the late antique style of his models into a new and essentially medieval one. The delicate gradations of colors and golden highlights of the garments define surfaces into precise, sometimes even geometric, relief patterns rather than model organic bodies. Indeed, the figures' movements almost seem to be dictated by the directions of the garments' folds. The measured gestures, as well as the relation of the figures to each other, express a calm absorption in the common task.

The introduction of a narrative author protrait of Saint Jerome might have had a special meaning at Tours. The preoccupation of the scriptorium with the creation of a standard Bible would have made such a frontispiece a fitting parable to the achievements of Alcuin.

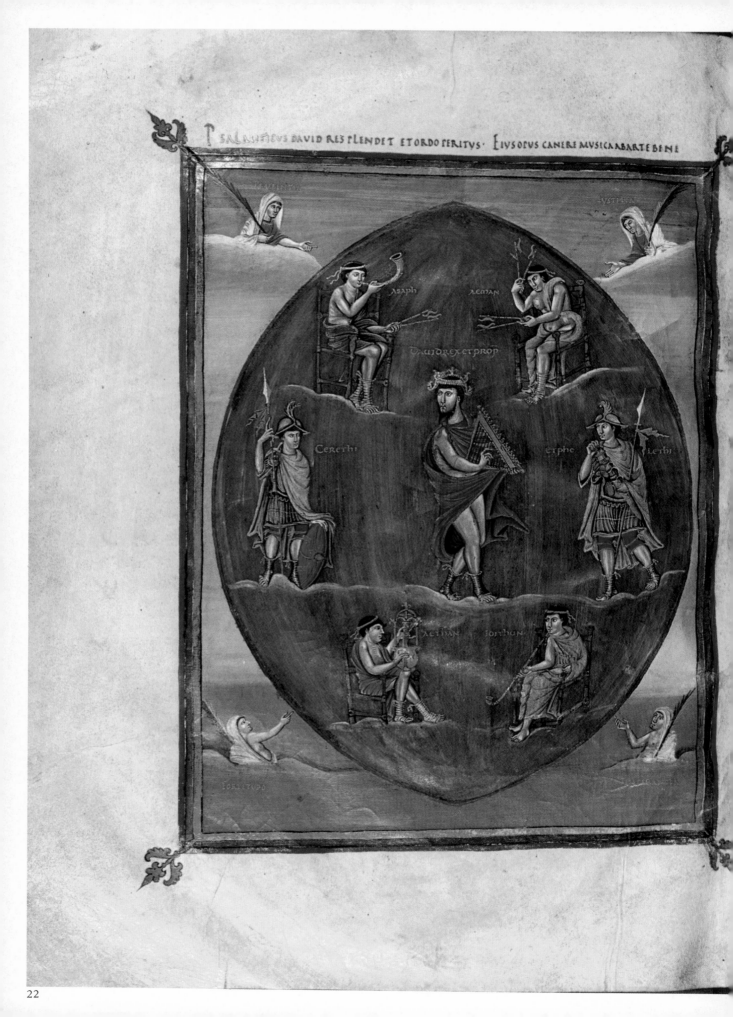

22

PLATE 22
VIVIAN BIBLE, fol. 215v: *Frontispiece to Psalms*

Although an author portrait, like the Saint Jerome miniature by the hand of the same painter (Plate 21), this frontispiece does not depict any particular event in the life of David, the author of the Psalms, nor any specific setting other than a celestial one, divided into an inner and outer realm by the large, pointed ellipse which has the almond shape of the glory or mandorla usually reserved for images of Christ in Majesty.

David, King and Prophet, occupies the center. Nude but for his crown, mantle, and military footgear, he composes the Psalms to the tune of his harp and the step of his dance on a cloudlike ground. To his right and left stand his guards, the Crethi and Plethi, who wear the armor of late Roman soldiers. Above and below, the King's chief musicians, Asaph, Heman, Ethan, and Jeduthun, accompany him with their instruments. Outside the mandorla, four palm-bearing female half-figures, Prudence, Justice, Fortitude, and Temperance, extend their right hands in acclaim toward the center.

The painter's command of late antique form is again apparent in the modeling of the nude bodies and garments, and one can be sure that his figures were taken from earlier sources. The half-nude, dancing David, for example, may have been derived from a representation of his return of the Ark of the Covenant to Jerusalem (I Chronicles 15:15–29; II Samuel 6:14–16), while images of David flanked by two female figures personifying his wisdom and power of prophecy are known in later Byzantine art. Once more, the master adapted and rearranged models from other contexts to a new purpose, just as he deprived the blue and rose background of its original meaning as natural sky in order to convey timeless and otherworldly domains.

Of course, other Carolingian artists in other ateliers had also imposed changes on their models, but few were as inventive as this painter. By completing the quaternity of the cardinal virtues—the lower ones half-nude, as not found elsewhere in late antique or early medieval art—the Touronian artist transformed a general theme of celestial inspiration into the specific and systematic one of the four cardinal virtues as complements to the four musicians and the central figure of David, very much like the correlation of Evangelist symbols, seated Evangelists, and Christ in Majesty pages (see Plate 23).

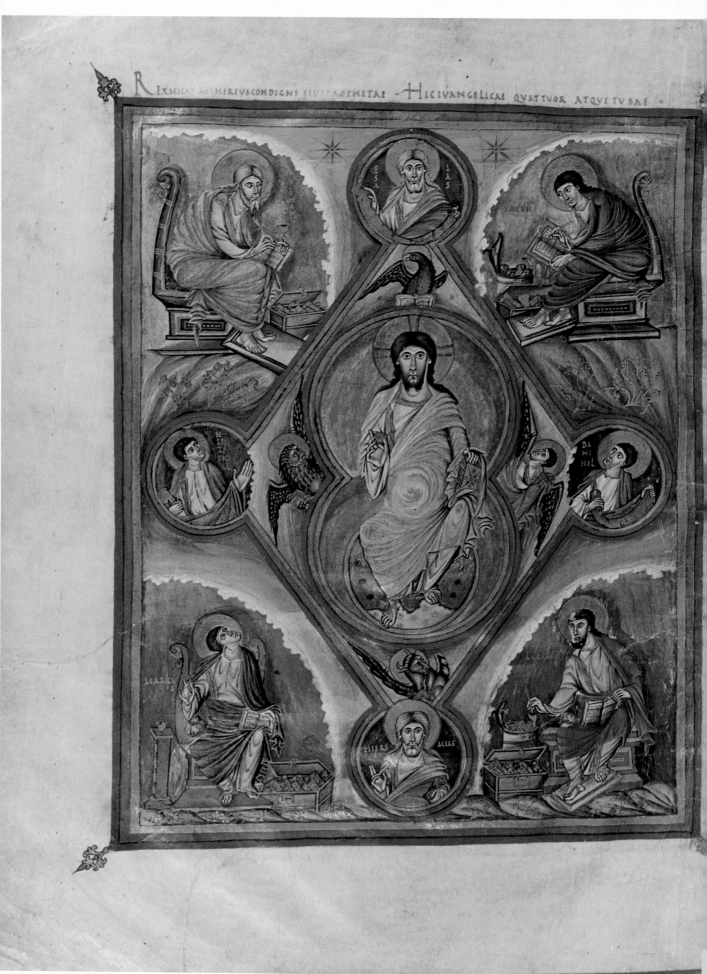

PLATE 23
VIVIAN BIBLE, fol. 329v: *Frontispiece to the Gospels—Christ in Majesty*

The return of Christ at the end of time, as predicted by the Prophets and revealed by the Apocalypse, is a theme which had found varied expression on mosaics or frescoes of Early Christian churches, East and West. While it had also entered manuscript illumination before the Carolingian period, it is in Touronian manuscripts that one can best observe its gradual translation into medieval meaning and form. The painter of the Majesty page of the Vivian Bible, the ingenious master also responsible for the Saint Jerome and David miniatures (Plates 21, 22), devised the most advanced composition by joining schematic structure, earth and sky background, and figures into an eschatological image which, appropriate to a Bible manuscript, unites Old and New Testament truths.

Christ, enthroned on a cosmic globe before a mandorla shaped like a figure eight, supports a closed book on his left knee and raises with his right hand the eucharistic wafer, the species of redemption. Adjoining this vision, the four apocalyptic symbols of the Evangelists appear between the mandorla and an enclosing lozenge frame whose form recalls early medieval cosmological schemes of the shape of the world. Medallions at the corners of the lozenge contain bust portraits of the four major Prophets who hold scrolls which represent Old Scripture while the Evangelists in the corners of the page have codices evocative of the New Testament.

Although the composition is determined by a conceptual order, the artist was deeply concerned with the problem of rendering figures in residual space. His points of departure, however, were in this instance not works of the late antique but of the Carolingian period, namely a Touronian Majesty image similar to that of the Grandval Bible and a manuscript from Reims, its style not unlike that of the Ebo Gospels (Plate 14). While no Reimsian Gospel Book is known to have contained a Majesty page, the effect of the style of Reims can be felt in the swirling pattern of golden highlights on the mantle of Christ. However, the Touronian painter subdued the inspired frenzy of the Ebo style into the contained firmness of plastic form also shown on his other pages.

PLATE 24
LOTHAIR GOSPELS, fol. 12r: *Canon Table*

The Gospel Book of Emperor Lothair is one of the finest—if not the finest—of the surviving manuscripts produced at Tours. There is good reason to believe that it was illuminated by the calligrapher and the best of the three painters of the Vivian Bible (Plates 21, 22, 23) whose mastery of means and artistic authority had now reached a maturity and refinement worthy of the imperial commission. In the work of these masters, more than of most others, one senses the innermost ideal of the Carolingian "Renaissance," namely the determination not merely to imitate antique form but to penetrate to its essence and to embody it in a new fabric for new expression.

Although richly adorned, the Canon Table reproduced here imparts an effect of perfect clarity and stability, a stability, however, that is not achieved by simulating solid architecture as on the Canon Tables of the Soissons or Ebo Gospels (Plates 5, 13). The delicate, silhouettelike metallic forms of frame, arch, and vegetal or beast motifs, as well as a sparing use of color, enhance the parchment surface rather than intrude upon it. Frame and arch provide the element of repose to which the equilibrium of the chapter numerals and their horizontal divisions is consistently attuned, while the same unerring sense of balance holds the large disk containing the Canon numbers in harmonious suspension. Yet, this stable order is capable of engendering plant and animal life beyond its confines: Straight borders turn flexible at the upper corners of the frame and metamorphose into beast heads sprouting acanthus leaves. A similar motif appears at the lower corners, but here the calligrapher's sense for tectonic propriety did not allow the borders to turn into interlace. The decorative extensions to both sides of the frame and on its top (flanked there by two heraldic lions), complete a page whose beauty lies in the measured orchestration of firm structure by letters and enlivening decor.

CA
INQ IIII
NI

MATT MARC LUCS IOHN

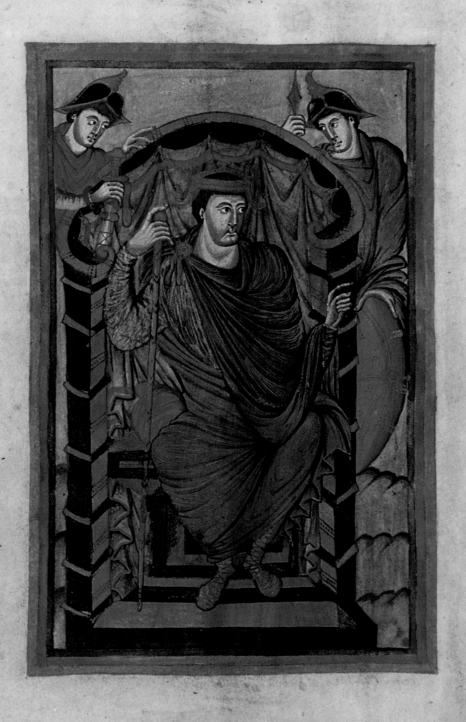

25

PLATE 25
LOTHAIR GOSPELS, fol. 1v: *Emperor Lothair*

The portrait of Lothair is certainly based on a representation of a late antique ruler, as is evidenced by the frontally seated posture, knees spread and one foot slightly drawn back, the right hand resting on the long scepter. The painter must have studied the style of his model very carefully, in order to bring out the mantle's natural fold-play and to lend to it the quality of a relief. These borrowed elements, however, are subsumed into an unmistakably Carolingian image which, on the one hand, evokes the vigorous physical presence of the Emperor and, on the other, firmly holds it on the page.

Almost entirely filling the frame and composed in an ascending order, the figure of Lothair, the throne, and the two nobles behind it occupy their own shallow layers of space. Some spatial depth is alluded to by the throne, but the main function of its curve is not to provide a seat for the Emperor's substantial body, but to contain his powerful head and broad shoulders. This containment, however, is countered by the turn of the head and the intense stare to the right, which is seconded by the pointing gesture of the left hand. In fact, the entire composition—although balanced in itself—is directed and opened toward the right. The throne is placed off center and the motion of the hands leads the eye from the upper left of the miniature to the right. Even the distribution of red color areas underlines this direction.

The change from a strictly frontal and centralized composition to one emphasizing movement toward the right makes eminent sense when the manuscript lies open because the facing recto page contains the golden letters of the dedicatory poem on a framed purple field. Lothair points to the verses which praise his rule, name him as the patron and donor of the Gospel Book to the Abbey of Saint Martin, and recommend him to prayers of intercession by the beholder of his image and the manuscript.

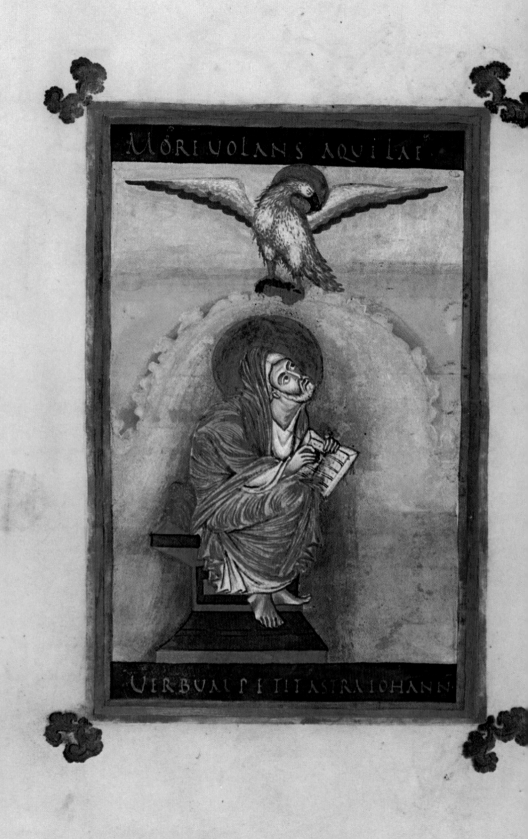

PLATE 26
LOTHAIR GOSPELS, fol. 171v: *Saint John*

With the portrait of the Emperor (Plate 25), the painter of the Lothair Gospels had achieved an image whose immediacy and power has no known precedent in Touronian and, indeed, Carolingian painting. His Evangelist portraits, however, evolved from long and assiduous efforts by Touronian artists to create ever new variations from an initial fund of models contained in a Gospel Book thought to have been produced in Rome sometime between 650 and 750. Step by step, parts of these models were interchanged and enriched by lessons absorbed from successively available late antique works and from the example of the Reimsian Gospels, whose stylistic influence was already felt in the Christ figure of the Vivian Bible's Majesty page.

Comparing the portrait of Saint John in the upper left of the Majesty page of the Vivian Bible (Plate 23) with the Saint John of the Lothair Gospels, one sees that the artist based the later figure on his earlier one, transforming the cavelike background of the Vivian page into a stratiform cloud which evokes the Evangelist's existence in an unearthly realm. Of course, for a separate page, the painter followed the old tradition of depicting the Evangelist communing with his symbol, just as he included on two purple bands, excerpts from the *Carmen Paschale* of Sedulius (first half of the fifth century) which, introduced by the Roman model, are found on all Evangelist portraits in Touronian Gospel Books. However, the most significant distinction between the two images of Saint John is an increase of expressive force in the Lothair Gospels and, above all, a remarkable advance in capturing the quality of cloth clinging to and defining the forms of the body. The expressive element seems to have been owed to a renewed study of the Gospel Book from Reims, whereas the new understanding of the behavior of thin cloth enwrapping a body must stem from a more intense perusal of late antique work. These two impulses control each other in the Lothair Gospels, lending to its Evangelists a particular energy, both psychic and physical. But in the Evangelist portraits of a slightly later Touronian manuscript, the so-called Dufay Gospels (Paris, Bibliothèque Nationale, lat. 9385), the antique element predominates to such a degree that one can speak of a "Touronian Late Antique," albeit a short-lived one because the scriptorium ceased to be a leading center after the Normans leveled Tours in 853.

Fluuius quem heridanum dicunt hab& stellas primo
flexu iii. secundo iii. tertio vii. quaedicuntur ora Nili.
summa xiii huic sub est stella quaecanopus appellatur.

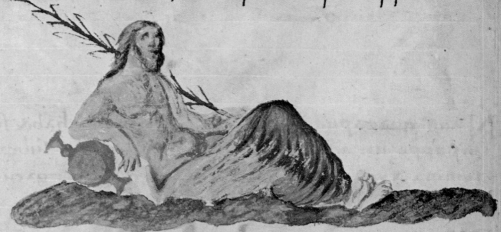

Piscis magnus hab& stellas xii. inordine positas acapite
usque ad caudam

Ara siue sacrarium. hab& stellas iiii duas inigne quiei
inpositus ard& . & inbasi duas.

27

PLATE 27
Astronomical-Computistic Manual, fol. 61v: *Eridanus, Piscis, Ara*

Carolingian scholars did not neglect Astronomy in their pursuit of the Seven Liberal Arts. In Einhard's *Vita Caroli* we read that even Charlemagne himself, "learned to reckon and used to investigate the motions of the heavenly bodies most curiously and with intelligent scrutiny." The observation of astronomical events is, of course, indispensable for calculating the movable dates of the calendar and we know that, in 809, the Emperor convened a group of scholars to attempt a reform of its computation. A result of these efforts was a manual which, though lost, is reflected in four incomplete copies of the ninth century.

Among these, the manuscript produced at Metz during the tenure of Drogo (823–855), and represented here by one page, contains the finest miniatures and the only fully painted ones. Although the figurations are without the stars marking the constellations as mentioned in the text, they clearly echo late antique archetypes. However, they are thought to have been copied from the manual written at the court of Charlemagne which must have been illustrated by one of the followers of the masters of the Coronation Gospels, then the only artists capable of reproducing the style and technique of late antique art. Still, a comparison with the Evangelist portraits of the Coronation Gospels (Plates 8, 10) shows that the Metz artist abandoned opaque colors and vigorous modeling for a technique of broadly applied washes of base colors and loose brushstrokes for shading. A similar technique is found again in the historiated initials of the magnificent Sacramentary made for Drogo during the later years of his tenure as Archbishop (844–855) (Plates 28, 29).

Although an illustrated luxury edition copied for Bishop Drogo, the manuscript was not just a bibliophile's treasure. It was kept up to date by later entries recording a solar eclipse in 840 and another one in 876.

quihodiernadie
perunigenitutuũ

PLATES 28–29
DROGO SACRAMENTARY, *Full-page Initials*: fol. 15v: *Te Igitur* fol. 58r:
Initial D with Easter scenes

The few manuscripts produced at the court scriptorium of Archbishop Drogo
of Metz are designed and illuminated with a finesse and ingenuity which may
well reflect the choice taste of that patron. While Drogo's artists and scribes
were certainly acquainted with the style of the Coronation Gospels and with
works from Tours, the sources for the ornamental forms and the hagiographi-
cal and sacramental cycles inserted into the initials of the Drogo Sacramentary
remain unknown. To be sure, historiated initials were used before, but nowhere
are Insular motifs so totally absent, or the classical elements of capital letters,
acanthus tendrils, and figures or scenes, combined with such harmonious ease
that none imposes on the substance of the other.

Unlike any other decorated initial outside Metz, the bars of the letter are
used as a trellis around and beyond which twines golden foliage. On the initials
T(e igitur), opening the prayer of the Canon of the Mass, the leaf tendrils on
the cross-like *T* enclose four fields with figures which refer to Old Testament
sacrifice mentioned in the Canon as prefiguring the sacrifice of Christ. In the
center, Melchisedek, priest-king of Salem, celebrates the Eucharist on an altar,
while gazing upward to the hand of God—as does Abel on the left, offering
the lamb, and Abraham on the right, holding a ram and pointing toward the
two bullocks at the foot of the letter, all three beasts being part of Old
Testament sacrifice.

The initial *D(eus)*, opening Easter Mass, encloses a representation of the
three women before the tomb of Christ receiving the angel's announcement of
his resurrection according to the Mass Pericope (Mark, 16:1–7). Two more
small scenes, not alluded to in the text, are added between the widening curve
of the bars of the *D*: Christ appearing before Mary Magdalen and the "other
Mary" (Matthew 28:9) and, below, Christ and Mary Magdalen alone (John
20:14–17).

Although the scene of the women before the tomb of Christ appears before
in the Utrecht Psalter (fols. 8r, 90r), where one also finds relatives to the
mobile small figures of the Sacramentary, such similarities do not assure a
Reimsian manuscript as the means of transmitting to Metz New Testament
cycles of ultimately Early Christian origin.

PLATES 30–31
So-Called Gospels of Francis ii, fols. 147v–148r:
Saint John and his Symbol

We do not know what unusual circumstance caused the Franco-Saxon scriptorium of Saint-Amand to suspend its traditional rejection of figurative imagery by including Evangelist portraits and symbols in this manuscript. Even their separation on two facing pages and under two arches is rare. Whatever the model available at Saint-Amand, it could hardly have taught illuminators, who were used to quite different techniques and modes, to paint miniatures of the quality seen on the pages reproduced here. An artist from another scriptorium must have arrived. His only significant concessions to local taste are the capitals which appear like the birds' heads interlace crowns of Franco-Saxon initials. From exactly where this painter came it is impossible to say, but his style is certainly indebted to the achievements of the art of Reims, as evidenced by the form of the trees. Those flanking Saint John may be compared with a tree in the Utrecht Psalter (Figure II), and the one in the center of the symbol page with that at the upper left of the Saint Matthew portrait in the Ebo Gospels (Plate 14). But unlike the Ebo masters, this artist, working more than a generation later, eliminated most vestigial allusions to atmospheric space by dividing the background within the arch into an even-colored foil for the Evangelist and a zone of cumulus clouds above. Likewise, the modeling of the Evangelist's mantle and tunic is of a firmness and clarity of design which differs entirely from the agitated surfaces of the Ebo period.

Although a similar trend toward tighter form also appears in later Reimsian miniatures at the time of Archbishop Hincmar (845–882), this is not sufficient grounds to connect this painter with an atelier located at Reims. By the second half of the ninth century, the exchange of manuscripts—and illuminators—had created complexes of related and yet different styles among far flung scriptoria. In fact, works reflecting Reimsian example were produced throughout the Carolingian Empire from northern France to southern Germany.

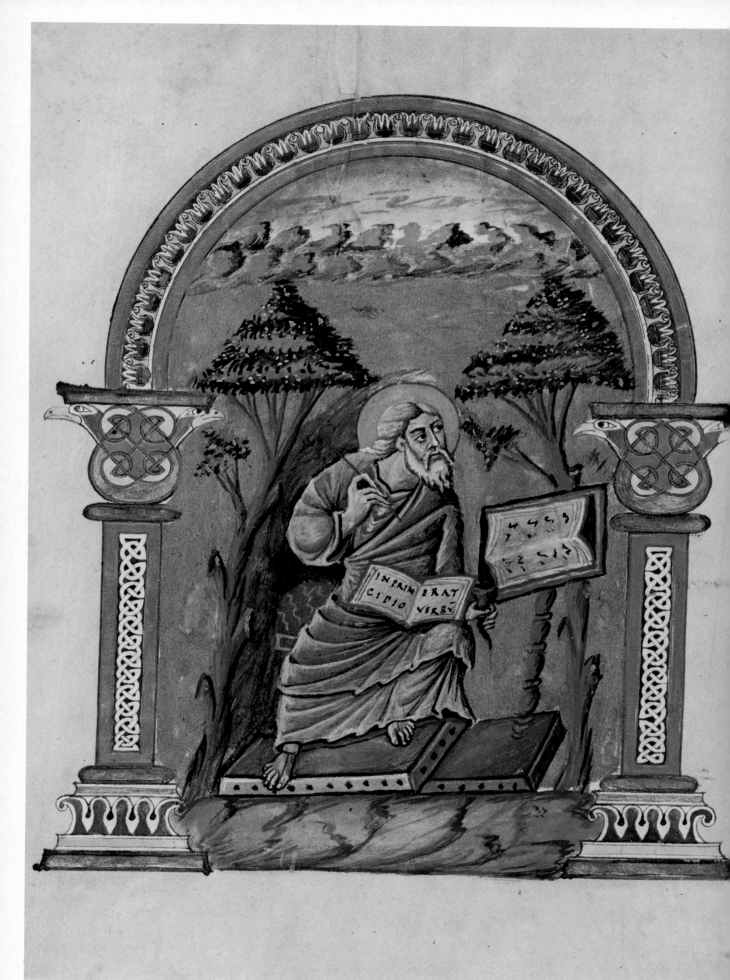

PLATE 32
SACRAMENTARY FRAGMENT FROM METZ, fol. 3r: *Saint Gregory*

An appropriate illustration for a Sacramentary, this page depicts Saint Gregory the Great, the author of the Mass formulae in Carolingian use since the liturgical reforms initiated by Charlemagne. While the composition reflects a late antique scheme for the representation of a high dignitary dictating to two smaller scribes, the miniature's particular content is based on a legend which relates that Saint Gregory, when dictating his Homilies on Ezekiel, often paused for a long time. The scribe, being separated from the Saint by a curtain, was puzzled, and he made a hole with his stylus through which he saw the dove of the Holy Ghost hovering at the head of Saint Gregory, who resumed his dictation only when it removed its beak from his mouth.

In this earliest known rendering of the story of divine inspiration, the curious scribe nimbly lifts the curtain rather than piercing it, as seen in later medieval miniatures. His action emphasizes the anecdotal element and gives motion and life to the image. In impressive contrast to the calm of the Saint and the space he occupies, such a sense of movement pervades most other details of the painting: the rippling clouds, the irregular drapery folds of the curtain, the frilly hems of the scribes' tunics, the sketchily applied highlights which enliven the surface of their garments as much as model it, and even the undulating course and shifting directions of the lush acanthus palmettes of the broad frame.

The rich and elaborate frame is a typical feature of the Court School of Charles the Bald, whereas the style of the painting is clearly rooted in Reimsian art. But, characteristic of this late phase of Carolingian illumination, and especially, of the eclectic climate of the Court School, the artist also drew on forms and motifs developed in other scriptoria. On this page, for example, one can trace his debt to Tours in the figure of Saint Gregory which may be compared to the portrait of Saint Jerome in the Vivian Bible (Plate 21).

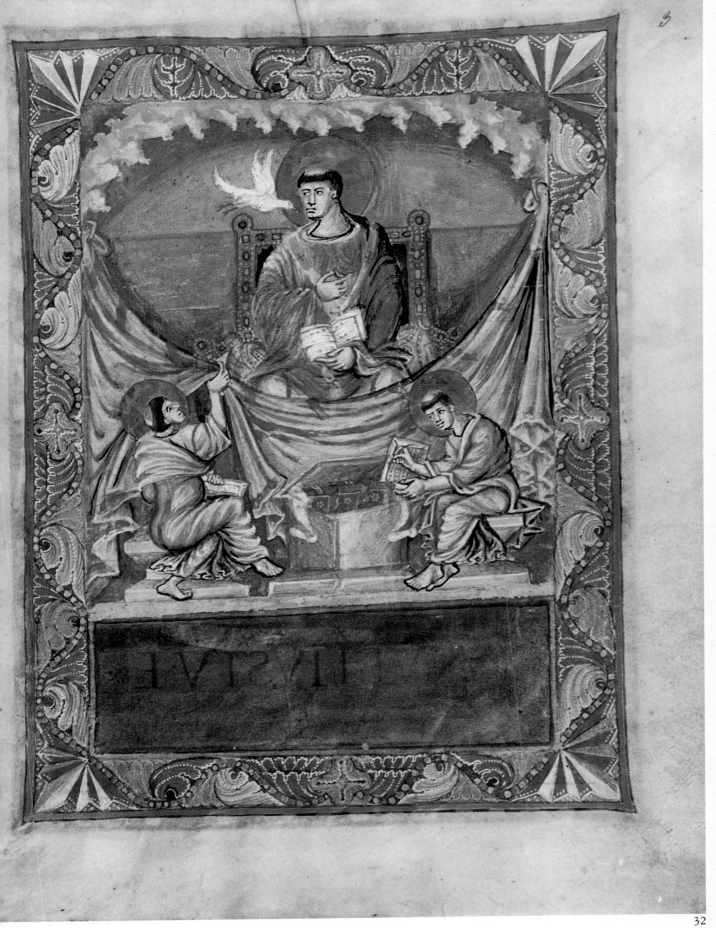

PLATE 33
SACRAMENTARY FRAGMENT FROM METZ, fol. 5r: *Christ in Majesty*

The *Praefatio* to the Mass Canon, written in golden uncials on the facing verso page, is translated into a vision of exuberant splendor. Christ is seated on the cosmic globe and encompassed by a mandorla sustained by the four Evangelist symbols. As in the Vivian Bible (Plate 23), he holds the closed book on his knee with his left hand and offers the Host with his right. On three tiers to the sides and below, the choir of angels and a Seraphim adore his Majesty in accordance with the text of the preface. Four wingless men crouch behind the wavelike strip of the third tier, as if on a balcony, and glance in awe toward the Lord's apparition above. They must represent the Evangelists although they are not, as usual, varied in type.

Each figure, indeed the whole page, is filled with a verve and ardor which, though clamorous and directed here, recalls the frenzied exaltation of the Evangelist portraits of the Ebo Gospels (Plate 14). Again, one senses the spirit of Reims but also recognizes the Touronian element, not only in the use of the Majesty formula, but also in the organization of space into layers, one segment partly extending over the other in an ascending order. The frame, however, is different from both Reimsian and Touronian work. The outer gold band set with gems in imitation of goldsmith work, as well as the division of the inner part into sections—some simulating porphyry—are inspired by the frames of manuscripts from the Court School of Charlemagne (Plates 1, 6, 7). As on the miniatures of this first great phase of Carolingian illumination, the frame is again made an integral part of the whole. But the ornate solemnity in the decoration of the earlier works has now been replaced by the qualities of preciousness and ornamental profusion, in order to complement the colors and agitated forms of the image.

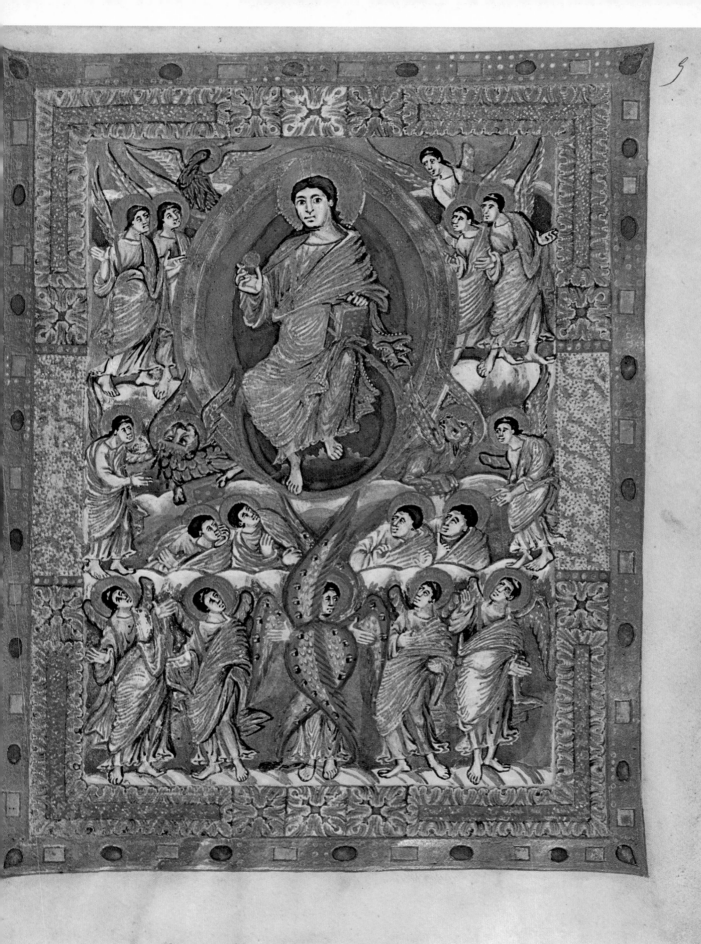

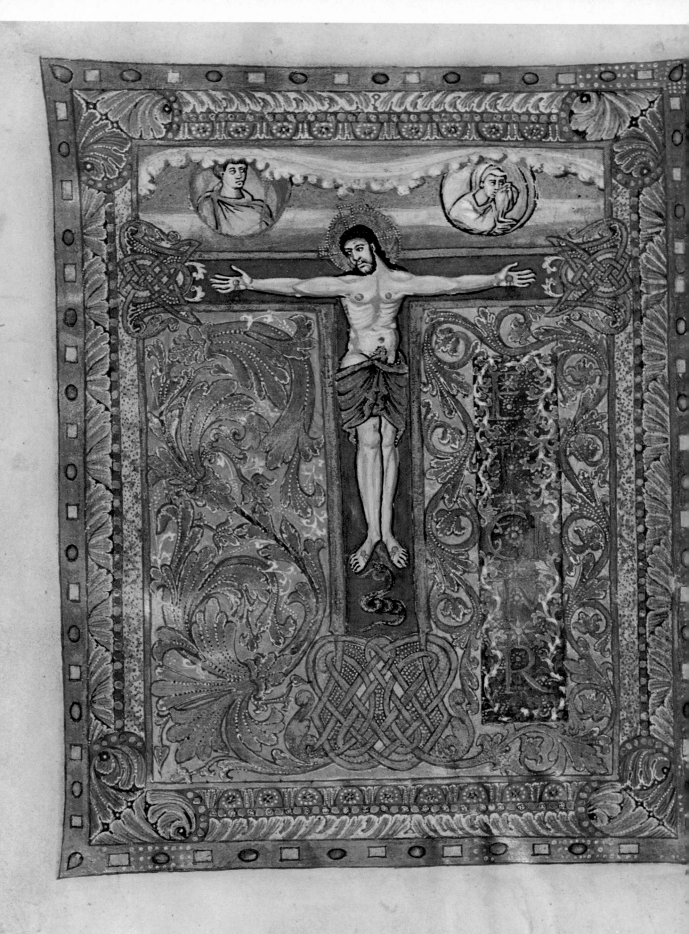

PLATE 34
SACRAMENTARY FRAGMENT FROM METZ, fol. 6v: *Initial—Te Igitur*

The initial at the beginning of the Mass Canon has been transformed into an opulent framed image. While in the earlier Drogo Sacramentary the sacrifice was evoked by Old Testament prefigurations (Plate 28), the master of the Sacramentary Fragment placed Christ himself on the letter *T*. Eyes open, arms stretched horizontally, he is the living Christ, triumphant over death, which is signified by the serpent below his feet. The personifications of sun and moon appearing in disks above the cross bars are a traditional feature, conveying the cosmic import of Christ's sacrifice on the cross, although the unusual turn of the grieving female moon toward the right may here refer specifically to the eclipse which occurred at the death of Christ.

The composition is ordered by the letter *T* and dominated by the figure of Christ on its blue background. The golden bars of the borders, however, continue at the terminals into interlaced bands from which, in turn, grow luxuriant acanthus vines filling the entire light green field below the cross arms. These golden vines reveal yet another source for the pictorial and decorative vocabulary of the Fragment's master, namely acanthus forms used earlier in the scriptorium of Drogo of Metz (Plates 28, 29). But this artist did not twine the vines around the letter. As offshoots from the interlace terminals, they seem to have been given the capacity of independent and more substantial growth—and they accompany the letters on their own. With a perfect sense for the equilibrium between static form and plant life, the artist surrounded the vertical purple field on the right, bearing the capital letters which complete the words of the initial, with smaller and more numerous convolutions than on the left, where the acanthus vine unfolds its leaves in one grand motion. The diverse motifs of the frame are again ordered to respond to the wealth of the image, and are bound with it into one splendid whole.

PLATE 35
CODEX AUREUS OF SAINT EMMERAM, fol. 16r: *Saint Matthew*

If it were admissible to look at early medieval works of art as reflections of the personality of their patrons, thinking of the inspired fervor of Reimsian painting during the period of Ebo, the conquest and conceptual reshaping of late antique models at Count Vivian's Tours, or the inventive but superbly controlled art of Metz under Drogo, one would have to say that Charles the Bald was infatuated with opulence, most conspicuously in the Codex Aureus of Saint Emmeram, the crescendo and grand finale of the work of his Court School. Of course, more verifiable historical causes contributed to this final efflorescence of court art, namely the King's ambition to attain the imperial glory of Charlemagne, and his ability to draw masters trained elsewhere to his court atelier, placing at their disposal a library encompassing major achievements of Carolingian illumination.

This portrait of Saint Matthew is a case in point. While the Evangelist is seated under an arch, as in the Gospels of Saint Médard of Soissons (Plate 6)—which is certain to have been known to the artists of the Codex Aureus—the Reimsian example is unmistakable in the position of the small symbol behind the cloud rim above, where, incongruously, plants grow as they do on the high hills of the Evangelist portraits of the Ebo Gospels (Plate 14). Even Touronian features may be discerned. The towerlike buildings serving as book repositories have a precedent, for example, on the Saint Jerome page of the Vivian Bible (Plate 21), and the involved drapery of the Evangelist's garments, overlaid with agitated highlights reminiscent of Reimsian art, still echoes forms found more coherently applied in the miniatures of a Touronian Gospel Book from Prüm, also of the Vivian period (Berlin, Staatsbibliothek, Theol. lat. F. 733). Nevertheless, a distinct style is created from these heterogeneous influences, a style which consolidates the picture surface by bright color, and the jewellike splendor of decorative patterns.

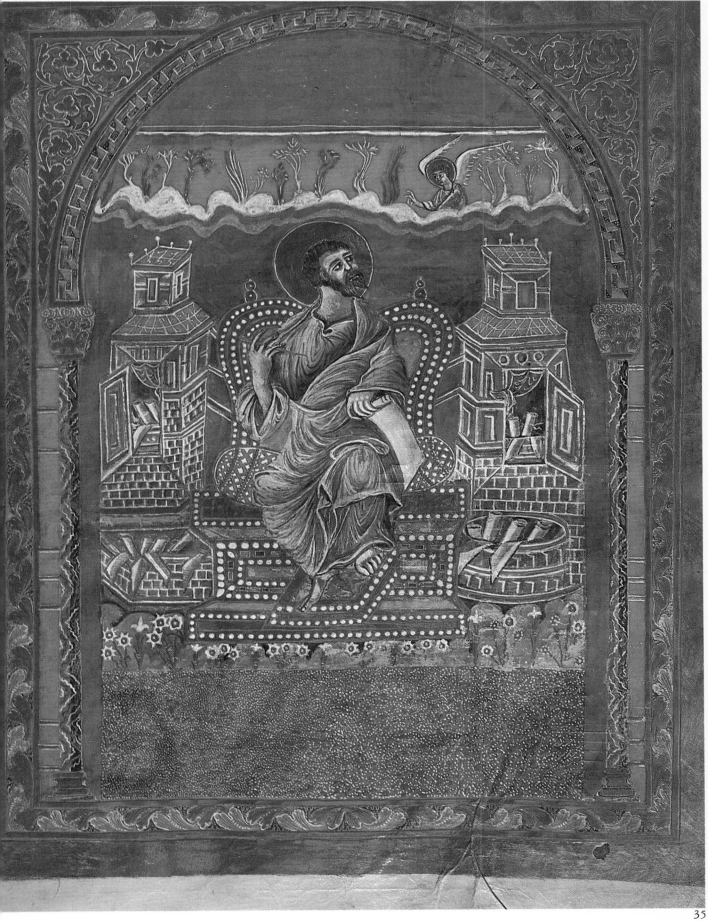

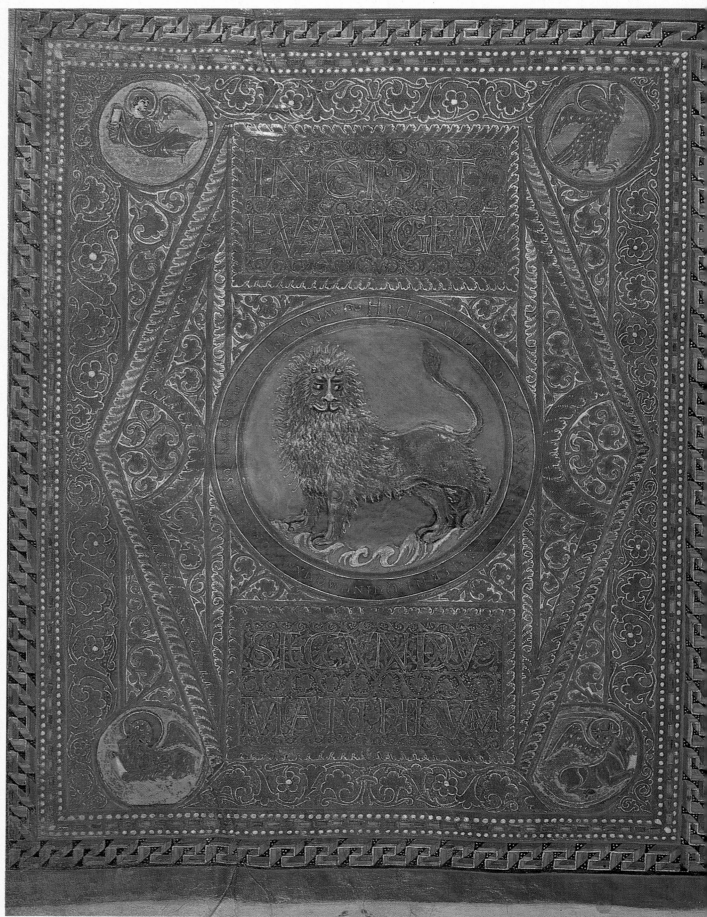

PLATE 36
CODEX AUREUS OF SAINT EMMERAM, fol, 16v: *Incipit page to the Gospel of Saint Matthew*

The desire to achieve a coherent surface of sparkling decorative wealth, observed on the Evangelist portrait, has been given full rein on the *Incipit* page. Free from the demands of a traditional theme, the master created a carpetlike fabric in which outer and inner frames, letters, and golden palmette scrolls are densely interwoven on a purple background, to hold corner disks with the symbols of the Evangelists, and a large center medallion containing a majestic lion.

Hardly an *Incipit* pure and simple, nor even a decorated *Incipit* initial page, the miniature presents a metaphor of the Majesty of Christ. The verse in the frame surrounding the lion speaks of his victory over death and his everlasting wakefulness. This allusion to Christ was inspired by the allegorical descriptions of the *Physiologus*. Christ's victory over death is signified by the third nature of the lion who is born dead but comes to life on the third day as Christ was resurrected on the third day, while the text on the lion's second nature tells that "he does not sleep nor will he sleep, who watches over Israel."

But not only the idea of representing Christ as a lion is owed to the *Physiologus*, the rendering of the beast also seems indebted to the paintings of the *Physiologus* manuscript from Reims (No. VII) although none of the lions depicted there have quite the same piercing eyes or imposing presence. This aspect must be credited to the skill of the court artist. If his gift for invention was as great as his command of artistic means, then we may perhaps also attribute to him the concept of transforming an *Incipit* page into a variation on the Majesty theme, not only for Matthew but for the other Gospels as well: a standing Christ on the page to Mark, the Lamb on that to Luke, and the hand of God on the *Incipit* to the Gospel of John.

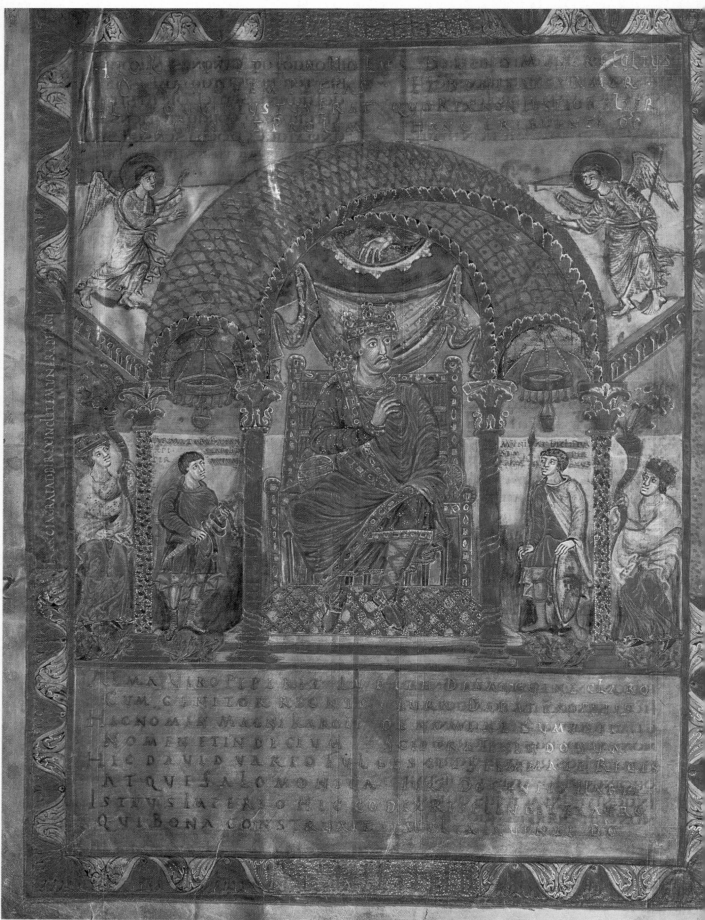

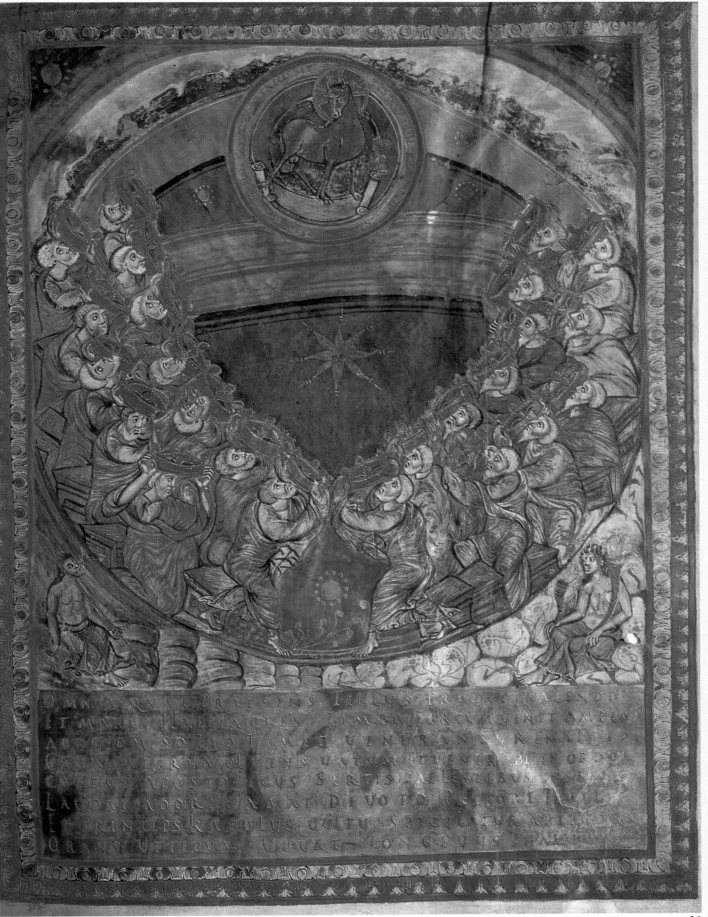

PLATES 37–38
CODEX AUREUS OF SAINT EMMERAM, fol. 5v: *Throne of Charles the Bald*
fol. 6r: *The Adoration of the Lamb*

Verses, written in gold rustic capitals on purple panels above and below the throne effigy, identify the King as Charles the Bald and link him to his biblical ancestors David and Solomon, indicating further that the codex was made on his order, and that he gave the gold for it.

Charles is seated below a canopy set on four columns. Although the rendering of the canopy implies spatial depth, its columns are brought into one surface plane, thus creating an essentially two-dimensional and hieratically ordered setting (compare Plate 44). The hand of God appears in a circular segment above the King to convey divine protection, as do the two guardian angels descending toward the canopy from left and right. Two men, much smaller than the King, stand under the lateral canopy arches and hold the arms which, as the inscriptions above them say, are to serve Christ against his enemies. Next to them, below obliquely ascending beams between canopy and frame, stand two female figures proffering cornucopias and wearing mural crowns, like antique personifications of cities or provinces. According to the words in the frame, they represent *Francia* and *Gotia*.

Beyond its palatial splendor, the architectural framework is given a sacral meaning by the golden *coronae* which, commonly hung in churches, are suspended here from the side arches of the canopy. On one level of meaning, the image is to evoke the King's rule under divine protection; on another, he may be thought to be seated in the western gallery of a Carolingian church, the place reserved for the royal or imperial presence during services, where he partakes in the Adoration of the Lamb by the Twenty-Four Elders, depicted on the facing page, toward which his glance and the gesture of his right hand are directed. In fact the last two lines of the verses under the Adoration miniature affirm that Charles views the revelation of the Lamb, praying to live with it in eternity.

PLATES 37–38 *(Continued)*

The vision in the Adoration miniature unfolds in a celestial orb above Sea and Earth, represented by their antique personifications, and emphasizing its cosmic import. Heads upturned, the Twenty-Four Elders rise from their seats in vigorous movements to offer their crowns to the Lamb standing in a framed medallion before multicolored heavenly spheres, stars, and a rainbow. While based on the Book of Revelation, the image compresses events narrated in chapters 4 to 8 into one grandiose theophany. Missing are the four apocalyptic symbols that appear in the miniature of the Gospels of Saint Médard of Soissons (Plate 4). Also, the Lamb stands now on the opened scroll, indicating that Revelation has been fulfilled, and the chalice, as well as the inscription in the frame of the medallion, refer to Christ's sacrifice on the cross and to the Eucharist celebrated by the congregation.

The Apocalypse theme is adjusted here to the context of liturgy, as would be appropriate for church decoration such as the mosaic of the Adoration of the Twenty-Four Elders in the dome of the palace chapel of Charlemagne at Aachen. Whether, as is likely, the miniature was inspired by this particular mosaic or not, its circular composition as well as its visual and thematic relationship with the opposite throne effigy surely take up a concept first realized in Carolingian church architecture and decoration.

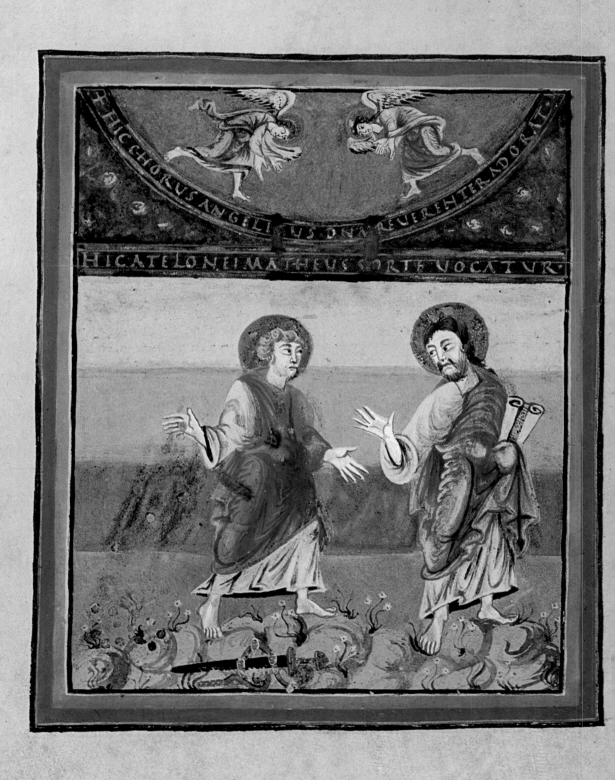

The top-right shows "24" handwritten. Bottom right "40".

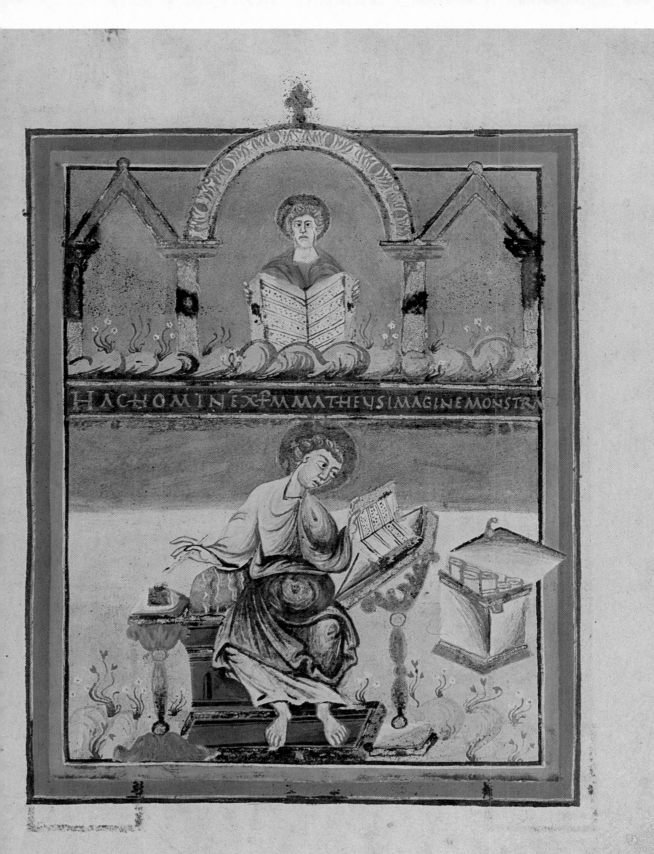

HACHOMINEXFMMATHEVSIMAGINEMONSTRA

PLATES 39–41
GOSPELS, fol. 23v: *The Calling of Saint Matthew*; fol. 24r: *Saint Matthew*; fol. 127r: *Initial to the Gospel of Saint Luke*

Of the few known Franco-Saxon Gospel Books provided with Evangelist portraits (for instance Plates 30-31), this is the most interesting because it prefaces the portrait pages with others depicting biographical scenes which show how the Evangelists came to be the authors of the Gospels. Reproduced here is Christ calling Matthew the customs-collector who has dropped his sword and casts coins away to follow the Master while, from above, two angels witness the event in reverent adoration. The others represent Saint Mark receiving the Gospel from Saint Peter, Saint Luke accepting his from Saint Paul, and Saint John leaning on Jesus' bosom at the Last Supper when, according to legend, he was inspired to write his Gospel. Unique in Carolingian art, these images seem to reflect a late antique pictorial cycle of the lives of the Evangelists in which the theme of their Calling was to confirm the authenticity of the four Gospels. This cycle has also left traces in the pairing of Saints Mark and Peter and Saints Luke and Paul in Eastern manuscripts of later dates. The same source may also have been responsible for the unusual rendering of the symbol of Matthew on the portrait page where the "man" is shown without wings within an architectural framework.

The initial pages, on the other hand, particularly the splendid framed *Q(uonia)m,* betray a fully developed, almost overripe phase to the Franco-Saxon style by the flexibly interlaced beasts which fill the framed background with their motions in strong contrast to the static equilibrium of the letters and frame (compare Plate 17). Such amassing and juxtaposition of colorful ornamental conceits, as well as the introduction of so many foliage motifs, are unknown in manuscripts from Saint-Amand, the leading center of the Franco-Saxon style. The precision and clarity of the design of the frame, however, are so closely related to the decoration of the so-called Second Bible of Charles the Bald (Plate 48) that there must have been an intimate knowledge of Saint-Amand productions at nearby Saint-Vaast. Nevertheless, this scriptorium retained its own ornamental idiom, favoring the rich over the restrained. Although constructed with an entirely different decorative and coloristic vocabulary, the magnificence of such a page is not far behind the contemporary work of the Court School of Charles the Bald.

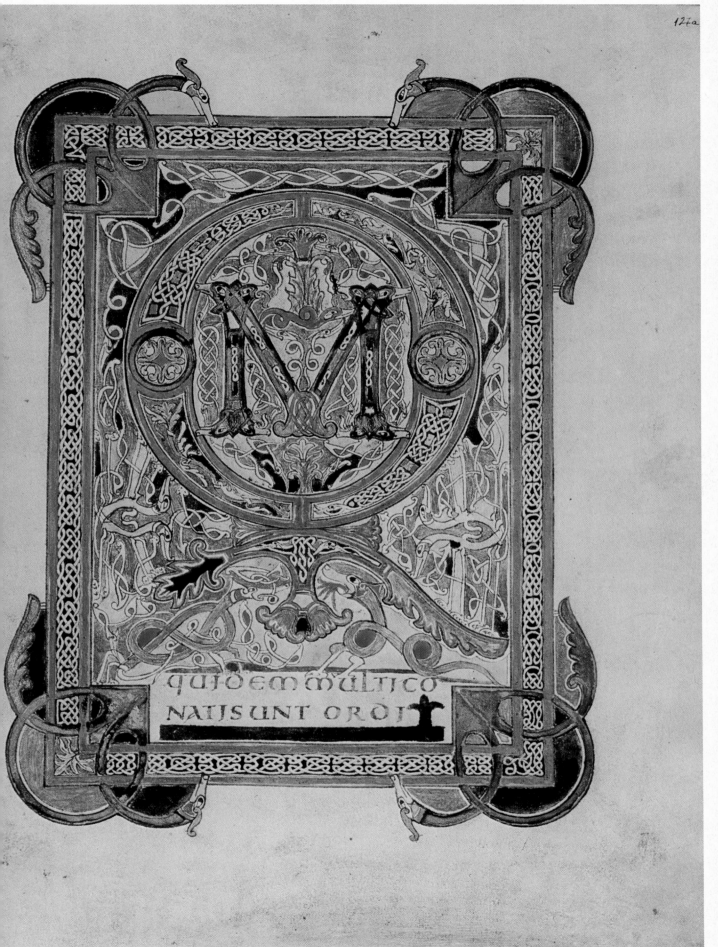

quidem multico
NATIS UNT ORDI

PLATE 42
BIBLE OF SAN PAOLO FUORI LE MURA, fol. 10(viiii)r: *Initial page to
Genesis—In Principio*

This grandiose overture to the Book of Genesis is but one in a sequence of thirty-seven magnificent framed initial pages which establish this manuscript as the most lavishly decorated Carolingian Bible known. These pages rival the splendor of the finest work of the Court School of Charles the Bald (Plate 36), although they are less hybrid and lush. They preserve a good deal of the calligraphic integrity and metallic precision that distinguish the austere initials of the Ebo Gospels (Plate 15), no matter how much the interplay between letters and decorative motifs has been increased to create such a stunningly sumptuous page as the one reproduced here. The orchestration of pattern and motif always remains subordinate to the major statement of the letter, and the proliferating growth of fine golden interlace and vines is never allowed to overpower essential structure but sustains the free rhythm and balance of the letters on the framed field.

Although the artist used some motifs that also appear in Court School work, his style must have evolved in the consistent tradition and discipline of another scriptorium, and all evidence points to Reims. One can trace the advance toward ever more rich and stately initials from the Ebo Gospels to Reimsian manuscripts dating well into the second half of the ninth century, and one may also be certain that the Bible's calligrapher gleaned ideas and motifs from work done in other scriptoria, particularly Tours, but also the Court School of Charlemagne. While such accretion of forms parallels the contemporary efforts at the Court School of Charles the Bald, the artist did without such devices as golden borders decked with gems or panels simulating porphyry, emphasized by this school as a deliberate reference to past grandeur and power. Instead he brought the basic idiom of Reims to a climax of unsurpassed richness and elegance.

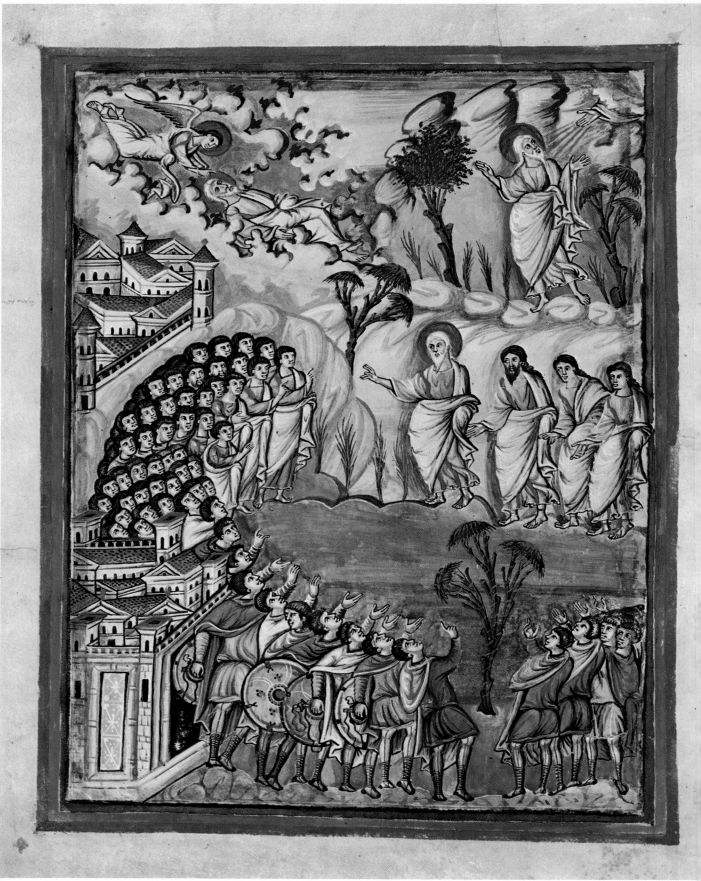

43

PLATE 43
BIBLE OF SAN PAOLO FUORI LE MURA, fol. 50(lxviiii)v: *Frontispiece to Deuteronomy*

This miniature depicts the final oration of Moses (Deuteronomy 1–32), his vision on Mount Nebo of the land of Canaan (Deuteronomy 32:49; 34:1–4), and his death (Deuteronomy 34:5–12). The people are gathered in a semicircle to receive the testament and the blessings of Moses. At his sides stand the forefathers Abraham, Isaac, and Jacob, to whose seed God had pledged the "promised land" (Deuteronomy 1:8; 34:4). Their presence removes the scene from a merely narrative context and lends to it the dimension of timelessness.

For these scenes, the painter must have been indebted to Bible illustrations which, ultimately of late antique origin, also included the apocryphal angel flying down to receive Moses into heaven. Not mentioned in Deuteronomy but in Jewish legends, this event is again illustrated in Byzantine miniatures which, although later in date than the Carolingian Bible, reflect its archetype. Equally significant for the history of early Bible illustration is the influence of Roman art, evident here in the attentive assembly which repeats a pictorial formula for the portrayal of a ceremonial act of state, namely the address of the Emperor to his troops, as depicted, for instance, on the triumphal columns of Trajan and Marcus Aurelius in Rome. Although invented about three-quarters of a millennium earlier, the connotations of faith and concord attached to this formula were still—or again—potent enough to determine the master's choice of the motif for the central theme of his painting to express the idea of promise and hope through faith. It is this scene which determines the structure of the entire composition. The curve of the assembly is extended into the contours of Mount Nebo by means of trees. Moses' death and apotheosis are in turn, connected with the scene of the vision by the ascending ground which, changing into cloud banks, serves as a foil for the Patriarchs, Moses, and the city to the left. While harmoniously distributed, the flatly applied opaque colors bounded by strong linear contours reduce the aspects of illusionistic corporeality and space which, more than two generations ago, had been introduced by the masters of the Coronation Gospels (Plates 8, 10). The scenes of this page are rooted in an even more distant past, but its style points to the medieval future.

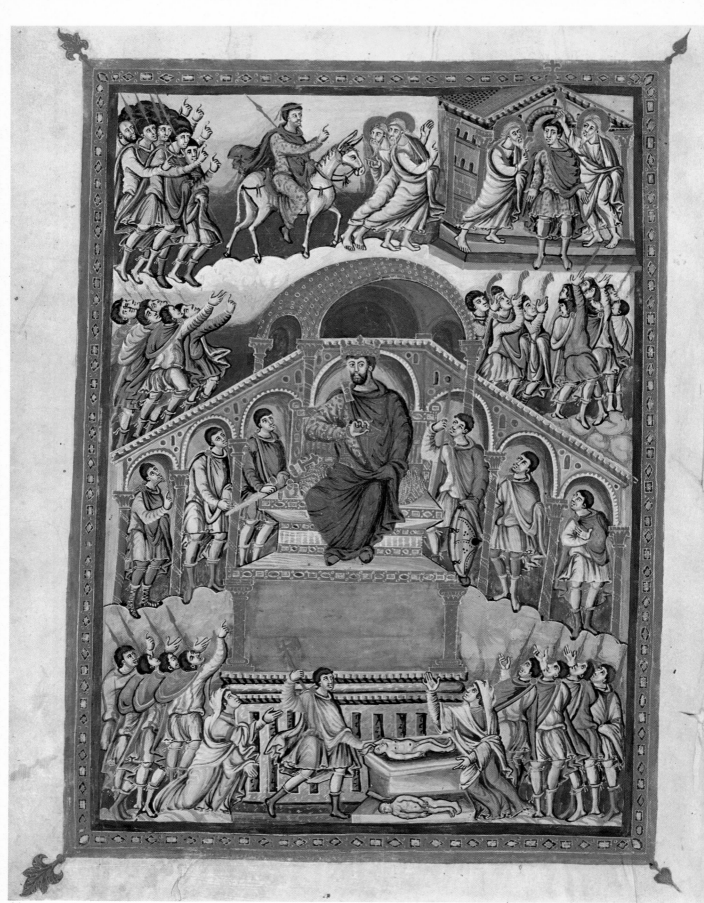

PLATE 44

BIBLE OF SAN PAOLO FUORI LE MURA, fol. 188(clxxxv)v: *Frontispiece to Proverbs*

By the hand of a painter other than the one responsible for the frontispiece to Deuteronomy, this page combines a throne image of Solomon, the author of Proverbs, with scenes from his life. In the upper left, Solomon rides on David's mule to Gihon to be anointed. He is led by "Zadok the priest, and Nathan the prophet" and followed by the "Cerethites and the Pelethites" (I Kings 1:33,38). To the right, Solomon is anointed by Zadok before the "Tabernacle" and below are the people who "blew the trumpets" and "piped with pipes, and rejoiced with great joy" (I Kings 1:39–40). Within an arcaded court in the center, and flanked by his nobles, Solomon is enthroned on a two-storied dais. At its foot are the two harlots, each of whom claims the living child which is threatened to be halved by an executioner. The dead child lies below (I Kings 3:16–28). Two groups of armed men look up to Solomon and acclaim his judgment.

Much larger than the other figures, Solomon dominates the page and faces the beholder. He is crowned like a Carolingian king and seated under a canopy like Charles the Bald in the Codex Aureus of Saint Emmeram (Plate 37). His purple mantle, however, has the golden inset worn by late Roman and Byzantine rulers, but not Carolingian ones. This small detail, as well as the similarity between the arcaded court and a mosaic in San Apollinare Nuovo at Ravenna representing the palace of Theoderic (ca. 500 A.D.), suggest that the painter was dependent on models which, like those for the Deuteronomy page, were strongly informed by the formulae of late antique imperial art. Even the scene of the Ride to Gihon recalls Roman representations of the *Adventus Augusti,* the ceremony celebrating the triumphant Emperor's arrival.

The models for the frontispieces to Deuteronomy and Proverbs may have been similar in style. This painter seems to have retained its allusions to spatial depth, which are much less evident on the Deuteronomy page.

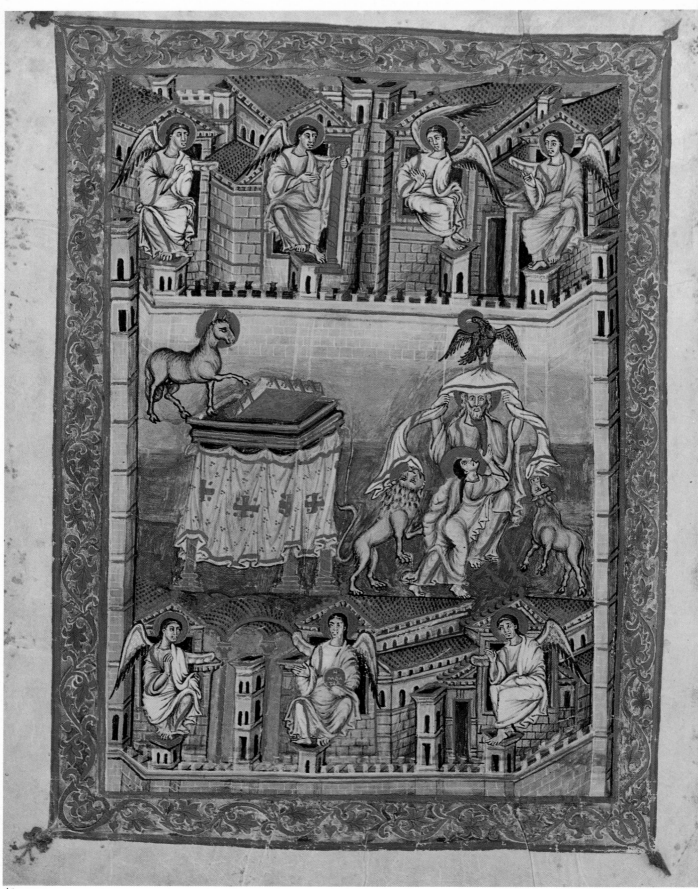

PLATE 45
BIBLE OF SAN PAOLO FUORI LE MURA, fol. 331 (cccxxviii)v: *Frontispiece
to Revelation*

Based on Touronian precedent reflected somewhat differently in the Grandval
and Vivian Bibles, this frontispiece, by the painter of the miniature to Proverbs,
represents the unveiling of the final truth as predicted in the Book of Revela-
tion. The verses of the title on the recto of the page read:

> "The innocent lamb who became a victim for us, rising victorious, removes
> the veil of the law; [He is] worthy to loose the seven seals of the book. Here
> the seven stars, by their foundation in true faith, designate in holy harmony
> the one procreation which begets those born in Christ, who are blessed
> without end."

The "seven stars" are the seven churches of Asia (Revelation 1:4,20; 2:1–19;
3:1–22), which are depicted as seven angels seated before buildings behind two
walls forming a court. Within this court, to the left, the Lamb opens the first
seal of the book (Revelation 6:1), which lies on a draped altar. The Lamb
looks to the right where a seated ancient holds a veil aloft that seems to be
lifted further by the talons of the eagle, while two other apocalyptic symbols, the
lion and the ox, hold its ends in their mouths. The "man" strides before the
ancient holding a golden horn.

This image and its Touronian counterparts, which show the symbols with
their usual wings, have been variously interpreted. Some scholars see in the
ancient the "one, like unto the Son of man" (Revelation 1:13–14; 4:2–8), who
is revealed by the apocalyptic symbols to the sound of "a great voice, as of a
trumpet" (Revelation 1:10; 4:1). Others suggest that he is Moses representing
the Old Testament unveiled by the symbols of the Gospels (II Corinthians
3:13–16). Whatever the case, the figure of the ancient is ultimately derived
from a representation of *Coelus*, the Roman god of the heavens.

The scenes are excerpts from an illustrated Apocalypse manuscript, one of
the descendents of an archetype which, as recently proposed, was created in sixth
century Rome. The availability of such a miniature cycle accounts for most of
the iconographic differences among the three Carolingian frontispieces. The
spacious architectual setting, however, found only on this painting, betrays the
artist's Reimsian background.

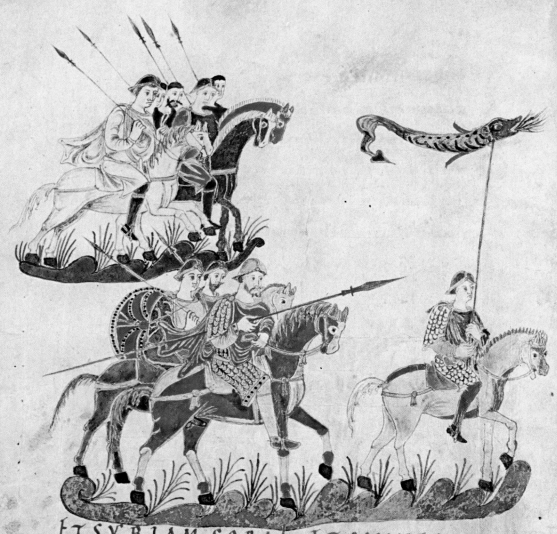

ETSYRIAM SOBAL · ETCONVERTIT
IOAB · ETPERCYSSIT EDOM INVAL
LESALINARYM · XII MILIA ·

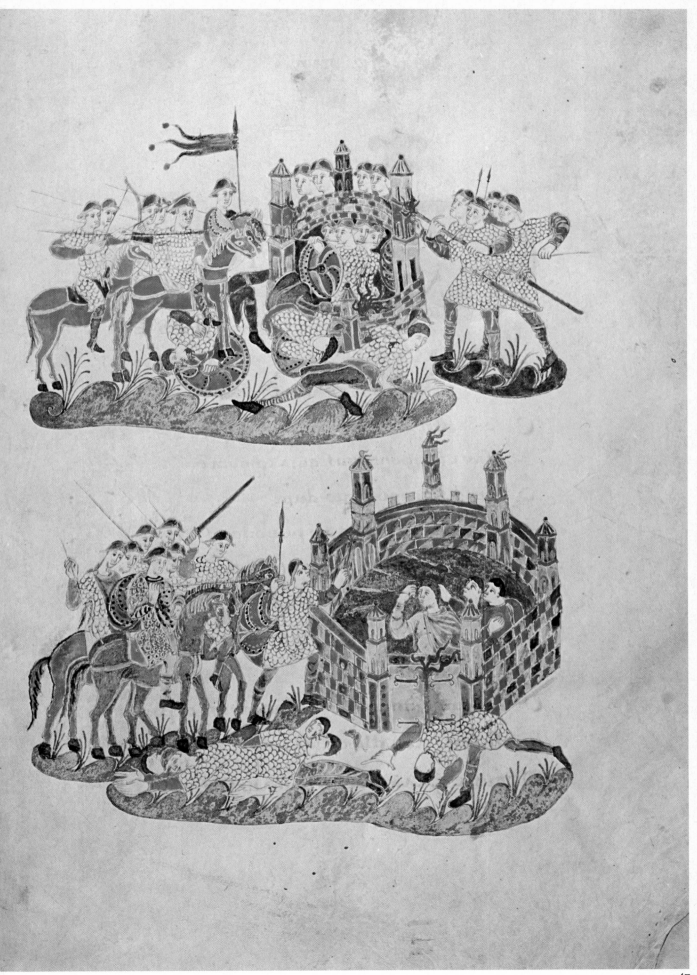

PLATES 46–47

PSALTERIUM AUREUM, pp. 140–141: *Illustrations to Psalm 59—The Campaign of Joab; Assault on a City; Surrender of a City*

While the monastery of Saint Gall had been a most active center of book production since the middle of the eighth century, it was only under its Abbots Grimwald (841–872), and, especially, Hartmut (872–883), that the scriptorium turned out illustrated luxury manuscripts which, though profiting from the example of work done in other Carolingian ateliers, still have a very distinct style of their own.

The Golden Psalter is the most famous of these manuscripts. In addition to author portraits of David and Saint Jerome on a purple background within gilt architectural frames, it contains narrative scenes drawn and colored directly on the parchment. Unlike the Utrecht Psalter drawings (Figures I,II), the scenes do not refer to the text of the Psalms but to the Psalm titles which briefly mention events from the life of David. The title to Psalm 59 tells of the exploits of David's general Joab in the wars against the Syrians and Ammonites and it is the most extensively illustrated. Three of its four scenes are reproduced here: page 140 represents the advance of Joab's host, page 141 the assault on a city, perhaps Rabbath (II Samuel 11:1), and below, either the same or another city about to surrender, its towers in flame.

Although these colored drawings are likely to have been based on earlier models, the artist used the pages left blank for him by the scribes with considerable ingenuity and freedom. A certain stiffness, for instance in the drawing of the horses, is offset by the riders' secure seat and varied gestures, as well as by the bold and suggestive *mise-en-page* of the advancing or attacking groups of horsemen and footsoldiers. No other Carolingian miniatures exist in which biblical events are rendered as if they were scenes of contemporary warfare. The chain mail of the soldiers is Carolingian and the standard held aloft by the leader on page 140 recalls a chronicler's description of the dragon banner carried into battle by Saxon warriors.

PLATE 48
BIBLE OF CHARLES THE BALD [*So-called Second Bible of Charles the Bald*],
fol. 11r: *Initial to Genesis.*

Produced at Saint Amand, a monastery favored by Charles the Bald, this Bible
holds a very special place amoung the manuscripts made for the King. It is illu-
minated with initials only and these are entirely different from those of the
roughly contemporary Sacramentary Fragment from Metz, the Codex Aureus of
Saint Emmeram, and the Bible of San Paolo (Plates 34, 36, 42). While ena-
mored with decorative exuberance and wealth, Charles evidently also had an eye
for the exquisite quality of this masterpiece, the final and greatest achievement
of the long and fruitful efforts of Franco-Saxon calligraphers to integrate
Insular motifs into rhymically balanced compositions.

 The framed *In Principio* page first impresses by its lucid order and sober ele-
gance. Widely spaced and perfectly proportioned, each decorated initial and
each letter stands on its own but also in equilibrium with the others and the
whole. The frame, unlike that of the earlier initial page of the Franco-Saxon
Psalter of King Louis (Plate 17), plays a major role by imparting its vertical
and horizontal stability to the interior design. Yet, the initials, however obedi-
ent to this order, still retain their own life: the animated tail of the *I* curves
outward, and the straight bars of the *N* are joined by a sinuous curve. Even the
austere capital letters are not placed exactly below the initial *N*, but are slightly
shifted to leave some open space at the right, as if hinting at the continuation
of the text on the next page.

PLATE 48 *(Continued)*

This sensitivity to the effect of an harmonious interplay between stable and mutable forms pervades all details which are drawn, gilded, and colored with extraordinary precision. Looking closely at the white and yellow interlace bands moving between the golden bars of the frame, one finds that the patterns do not match in a vertical or horizontal order but in a diagonal one, forcing the eye to move across the page, whereas the forms in the frame medallions are again made to correspond axially. In fact, each ornament joins in this play on directions with its own rhythm and colors. In the crown of the initial *I*, for instance, one observes how curves and volutes swell from a diagonally set multicolored geometric design in the center, to re-establish horizontal balance, while at the initial's tail more flexible and continuous interlace bands bind two beast heads into a symmetrical union that resolves the curving sweep of the bars into a vertical termination. Even the dot decoration alongside the large initial serves to maintain balance. Like the beasts' and birds' heads, the red dotted lines following the contour of the letter are borrowed from Hiberno-Saxon illumination. Here, however, the idea is extended to include trilobed leaves in green whose alternating directions create a delicate force-field which counterbalances the initial's vigorous verticality.

Patterns and colors constantly lure the eye from detail to detail and never allow it to focus for long on any single one. The page is experienced as a harmonious whole and the clear opening words of the Book of Genesis are never lost from sight. Despite the use of the dynamically complex vocabulary of Hiberno-Saxon origin, a work has been created whose monumental clarity and order may be termed more classical than any other initial page made for Charles the Bald elsewhere.

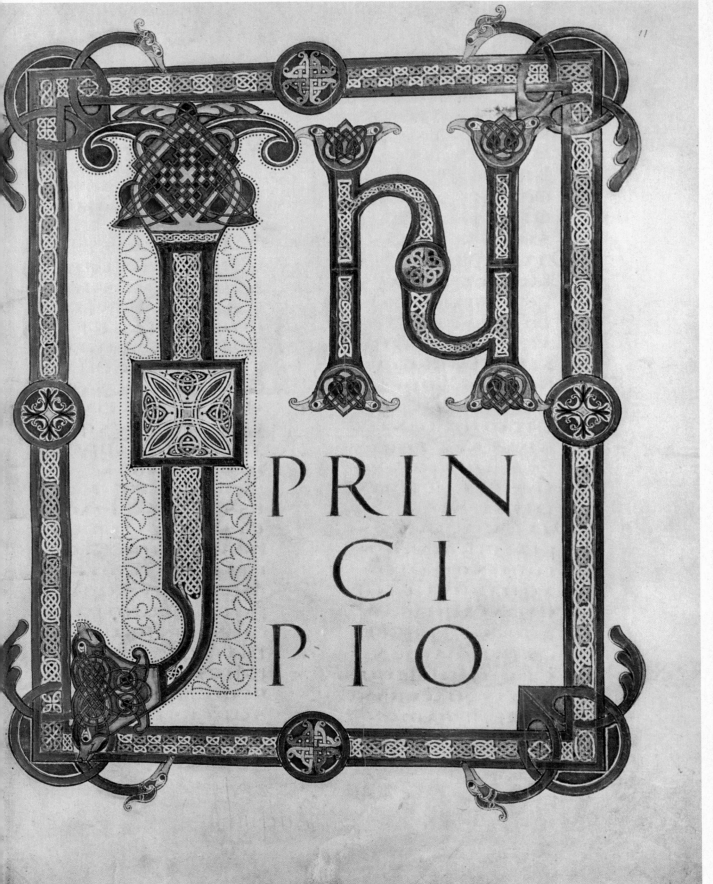

PRIN
CI
PIO